CREATE YOUR OWN
WALL ART
BY HENNY DONOVAN

BARRON'S

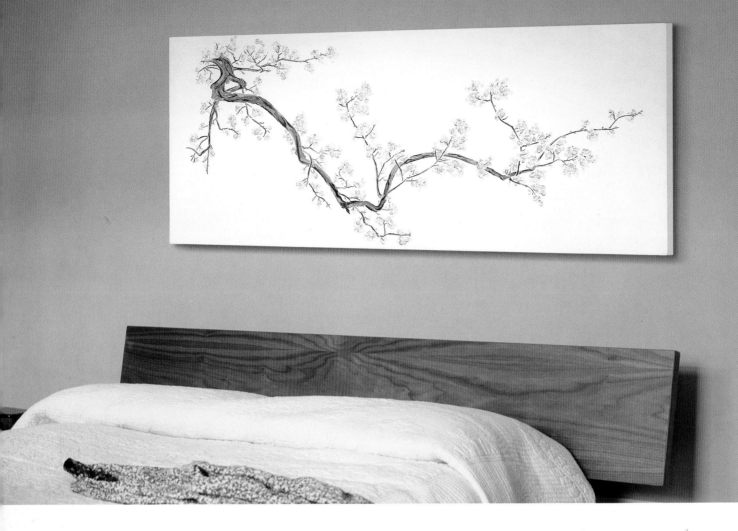

A QUARTO BOOK

First edition for the United States, its territories
and dependencies, and Canada published in 2006
by Barron's Educational Series, Inc.

All inquiries should be addressed to:
Barron's Educational Series, Inc.
250 Wireless Boulevard
Hauppauge, New York 11788
www.barronseduc.com

ISBN-13: 978-0-7641-3470-8
ISBN-10: 0-7641-3470-1

Library of Congress Control No. 2005933170

QUAR.AFW

Conceived, designed,
and produced by
Quarto Publishing plc
The Old Brewery
6 Blundell Street
London N7 9BH

Senior Editor Jo Fisher
Art Editors Anna Knight, Natasha Montgomery
Designer Claire van Rhyn
Assistant Art Director Penny Cobb
Picture Researcher Claudia Tate
Text Editor Tracie Davis
Proofreader Noo Saro-Wiwa
Photographer Philip Wilkins
Indexer Helen Snaith
Digital Artwork Alan Mole

Art Director Moira Clinch
Publisher Paul Carslake

Manufactured by Universal Graphic (PTE) Ltd,
Singapore
Printed by Star Standard (PTE) Ltd, Singapore

9 8 7 6 5 4 3 2 1

CONTENTS

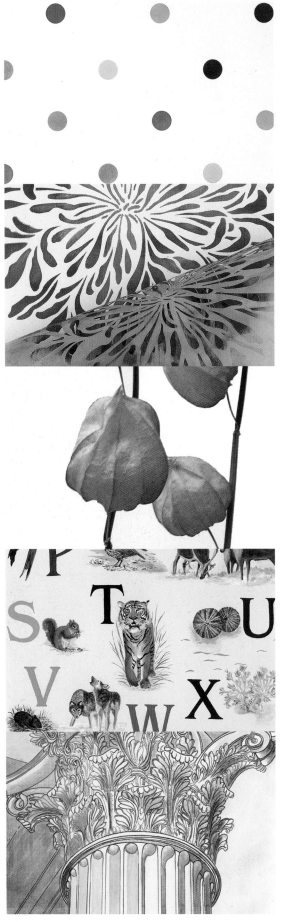

INTRODUCTION

Adding a creative touch to your home has moved on from simple room makeovers—now you can bring your living space alive with your own wall art. The modern home—whether it is sleek and contemporary, traditional, or a combination of the two—is a palette of expression, perfect for adding your own personalized art. This book is just the tool you need to do it! It contains 25 practical and inspirational projects using a range of both decorative and fine art techniques, so I have made sure there is something here for everyone.

If you have bare walls or rooms that are missing an interesting focal point and you cannot find what you like or what suits your interior style, creating your own wall art is an exciting way to produce something totally unique and customized to your particular living space. If you doubt your own artistic abilities, this book will make you think differently. You will certainly be surprised at the professional-looking results that can be achieved simply by following the step-by-step instructions.

HOW THE BOOK IS ORGANIZED

❑ The 25 projects are designed around the different areas of the home. The themes I've used complement different living spaces with subjects tailored to today's tastes and style preferences. There is a wide range of subjects to choose from, including botanical and animal themes, oriental themes, landscapes, portraits, and abstract art.

❑ The range of techniques used in this book is truly diverse, including landscape, abstract, and illustrative painting; pencil drawing; stenciling; fabric printing; lino printing; photography; textile collage; modern découpage; decorative gilding; mixed media techniques; and glaze work. Each technique is clearly

explained and illustrated in each project. Further instructions and information on the processes used in the designs are given in the "Techniques" section (pages 12–23), which also contains a useful introduction to basic drawing and painting skills.

❑ The projects and designs are applied to different surfaces in a range of formats. There are wooden panels in a variety of dimensions, different-sized canvases, horizontal, vertical, and block groups of boards, hanging fabric panels, and artwork in beautiful frames. This range of formats shows how you can fill all sorts of wall spaces with imaginative and striking wall art. A detailed section on preparation (pages 8–11) explains how to prepare battened boards, canvases, walls, and fabrics with a helpful chart of the materials and equipment you will need.

❑ Mounting, framing, and hanging individual pictures and groups of pictures is also covered (see pages 24–27). Advice is included on how to position work in room spaces on bare walls and in relation to furniture. The benefits of different lighting are looked at, along with detailed advice on color schemes for the backdrop of your picture.

❑ With the help of this book, you can create artworks that will enhance and enliven your home. You will learn many skills used by professional artists and will soon be able to decorate your home with your own individual art pieces rather than mass-produced posters or prints. You really can create your own wall art—and I know this book will show you how!

Henny Donovan

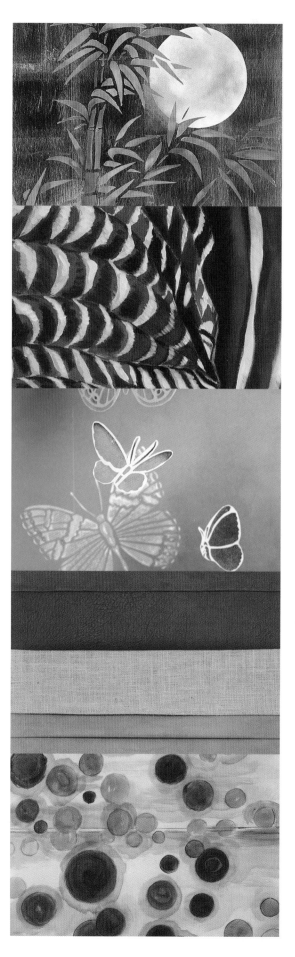

PLANNING YOUR ARTWORK

Thumbing through the different illustrated projects in this book is a good way to make a visual selection about the kind of wall art to create for your interior space. Before you make your final decision, consider the surface you will be working on, the room setting, and other factors that will influence the success of your piece.

DECORATIVE AND ARTISTIC STYLES

There are two approaches to the projects featured here: decorative and artistic. The decorative approach refers to projects where there is a strong pattern, texture, or structural element. The artistic approach refers to projects that involve painting, drawing, and photography. Both decorative and artistic styles utilize drawing skills in different ways. These two different approaches to the projects in this book create an extensive range of styles to choose from so there really is something for everyone.

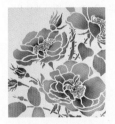

CHOOSING A THEME

The themes chosen for the projects here range between simple modern styles to classic subjects given a new twist. They have been chosen to encourage you to have a go and to spark your own ideas of what you can do. You can select from a choice of themes:

- **Botanical themes** include bamboo, agapanthus flowers, herbs, vegetables, water lilies, teasels, Chinese lanterns, giant hogweed, wild orchids, cherry blossoms, and wild roses. Themes from the animal world include butterflies, animal patterns, shell details, and animal illustrations for the entire alphabet.
- **Landscape and scenic subjects** include coastal scenes, fields of color, city views, architectural details, and a starscape.
- **Asian-inspired themes** include Chinese and Japanese calligraphy, bamboo and moon motifs, chinoiserie silk panels, kimono patterns, and a blossom bough.
- **Geometric subjects** include stripes of different colored textiles and fun polka dot patterns.
- **Portraits** are explored in the children's section.

DESIGN SOURCES

Once you have chosen a theme, collect design sources as inspiration for your project. Design sources might include pictures, natural and manmade objects, related subject matter, photographs, prints, and other artists' work—all to do with your theme and subject matter. You can also make pencil and watercolor sketches to get to know the subject. This collection will make valuable reference material for the fundamental design processes such as composition, color, and pattern. This method is used throughout the book.

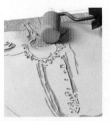

CHOOSING A TECHNIQUE

The choice of technique used to create your artwork is fundamental to the finished look. Different effects are created by using different techniques and the way a material is applied. Where you are planning to display your work will also have some influence on your choice of technique. The techniques to choose from here include painting, drawing, stenciling, fabric printing, lino printing, photography, collage, découpage, gilding, and glaze work.

SUITABLE SURFACES

Choosing the surface to work on, whether it is a board, panel, wall, canvas, hanging fabric panel, paper, or other, is also important in relation to the technique you choose in terms of suitability and finished look. For instance, a painting executed on a smooth gesso ground is very different in look and style to a painting on canvas. Each project gives advice on the best surface for the technique used and preparation techniques for these formats is given in the "Preparation" section on pages 8–11.

INTERIOR DESIGN CHOICES

As well as choosing a theme and a technique, there are some simple interior design choices to make. The function of the room and its existing style and layout are all factors to consider as well as where in the room the piece will hang.

Particular styles, themes, and techniques will enhance the overall feel and look of a room. An artistic painting can make a fantastic focal point to a room, while a decorative stencil may give a room character and structure.

The scale and format of your work is also a consideration. A single drawing on a large wall may appear lost, but the same drawing repeated or hung in a group with similar drawings will immediately fill the space better. Conversely, a large painting hung on a small wall, or in a room with a lot of furniture, will serve to crowd the space. Large pieces can work successfully in small spaces, but the space needs to have a clutter-free style to it to prevent an overcrowded busy effect.

COLOR CHOICES

The color scheme of a room can play an important part in planning your project. You may want your particular piece of art to have some of the color characteristics of the room it is to hang in and so harmonize with it, or you may want the piece to act as a contrast to the colors of the room.

It is important not to oversaturate one room with the same color, especially strong colors. A primarily red painting hung in a red room with dark wood furniture and lit with warm lighting will be totally overwhelming to the senses—it is generally a mistake to drench a room with one particular color. A painting in this instance would need to have a lot of contrast to add another dimension to the room—so adding a picture in striking black, or black and white, or white and off-white would help lift the mood.

CHOOSING FORMAT, SCALE, AND DIMENSIONS

Using different formats will allow you to adapt the scale and dimension of your artwork to suit the scale and dimension of the room in which it is to be hung.

For single large pieces of wall art, the best method is to work either directly onto the wall or onto a large battened board. Working onto a battened board (see page 9) gives you greater control as it can be moved easily.

A group of battened boards is a versatile format for creating artwork on different scales and dimensions, which can be helpful if you do not have a lot of space in which to work. A group can be hung successfully in both small and larger spaces, in vertical or horizontal linear groups, and in blocks of four, six, or more (see page 26). Boards can be painted and stenciled onto directly. Drawings, prints, and photographs can be mounted onto the board (see page 24).

Artist's canvas can be used for painting and stenciling with spray paints. You can work on a single large canvas or on smaller ones hung in groups.

Drawings, prints, and photographs can also be displayed in frames, either singly or in groups.

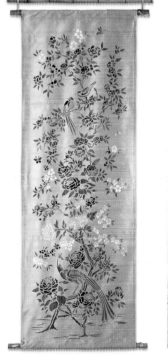

The Chinoiserie Panels project (above left and page 76) is worked on hanging strips of silk, while a battened board is used for the Botanical Mural (above right and page 44).

PREPARATION

The first stage of creating your own wall art is to prepare the appropriate surface on which to work. This section discusses the different surfaces that may be used, and lists the materials and equipment you will need. Some essential techniques are explained, including how to make a battened board— used widely in the projects—and preparing canvases.

PREPARING SURFACES

All of the projects indicate the different surface to use, but you can interchange these to suit your own room needs. The table below lists what materials you will need to prepare the various surfaces and structures used for the projects.

SURFACES & THEIR USES	MATERIALS AND EQUIPMENT
Battened boards and panels Painted boards are suitable for painting, stenciling, glaze work, découpage, and for mounting drawings and prints.	¼ in. (6 mm) MDF cut to size; 1 in. (2.5 cm) wide pine battens cut to the depth indicated in each project—two cut to full length of the board, two cut to fit remaining width of board; 120/180-grade sandpaper; PVA wood glue; ¾–1 in. (2–2.5 cm) panel pins; nail punch; hammer; plastic wood filler; palette knife; tack rag; acrylic matte varnish; matte emulsion or acrylic gesso primer; 1 in. (2.5 cm) artist's fitch, glider, or decorator's brush; 4 in. (10 cm) synthetic paintbrush or good-quality decorator's brush
Canvases on artist's stretchers Canvases are suitable for painting and spray stenciling.	Ready-made artist's stretchers for making up canvas frame; preprimed cotton duck canvas or plain unbleached cotton duck canvas with alkyd primer and wide decorator's brush; scissors; staple gun and staples; wooden wedges for corners; hammer or mallet
Walls as surfaces Painted walls are suitable for painting, stenciling, découpage, and glaze work.	Sandpaper or wet and dry paper in fine, medium, and coarse grades; flexible sanding block; interior filler for walls and plaster; filling knife; tack rag; protective clothing and dust sheets as required; PVA glue for sizing plastered surfaces; 2 in. (5 cm) masking tape; matte emulsion, acrylic gesso primer; acrylic matte varnish; 4 in. (10 cm) synthetic paintbrush or good-quality decorator's brush
Fabrics Suitable for printing or textile projects.	Fabrics cut to size; scissors; pins; iron-on hemming tape; ruler; tape measure; iron; ironing board; layout or tracing paper
Bench hook For lino cutting.	¼ in. (6 mm) MDF board 14 x 14 in. (36 x 36 cm); 2 lengths 1¾ in. x 1¼ in. (4.5 x 3 cm) wood 14 in. (36 cm) long; 1 in. (2.5 cm) panel pins; wood glue

MAKING AND PAINTING BATTENED BOARDS

MAKING BOARD

The depth of the battens used will alter the look of a panel. Deeper battens give the board a substantial appearance on the wall. Smaller battens help the piece blend into the surface. Details of depth dimensions for battens are given in each project. For larger boards, use a third batten across the middle to strengthen the structure. Let the wood stand at room temperature for a few days before making up to prevent it from warping.

STEP 1

Purchase a piece of ¼ in. (6 mm) MDF cut to the dimensions listed in your chosen project or to your own particular dimensions. Also purchase four pine battens as described in each project.

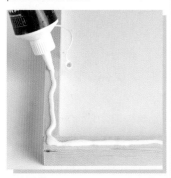

STEP 2

Sand the edges of the MDF board. Note: When sanding MDF, always wear a face mask to protect from dust.

STEP 3

On a large, flat surface, lay the battens down in the position they will be in once attached to the board, resting on their 1 in. (2.5 cm) width. Squeeze a line of wood glue along the upward-facing edge. Allow to stand for a few minutes, and then place the board on top.

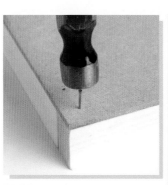

STEP 4

Ensure the battens are flush with the edges of the board. Starting with the length of the board, fix the longer battens using a hammer and panel pins along the outer edges. Place the pins at both corners and at 8 in. (20 cm) intervals. Repeat this for the two shorter battens. If adding a middle batten, glue it across the board and pin it to the two side battens. Do not use pins across the center front of the board.

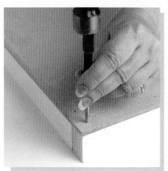

STEP 5

Let dry for ten minutes and then place a nail punch over each pin. Use the hammer to tap the top of the nail punch to sink the panel pins about 1/8 in. (3 mm) into the surface of the board.

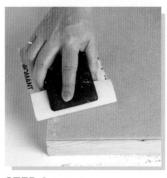

STEP 6

Use the plastic wood filler to fill each of these holes. Once the filler has dried, sand the rough edges until the surface is completely smooth.

PAINTING

Once you have made your board, you will need to select the base paint or primer. The type needed for each project is indicated throughout the book. As a general guideline, use matte emulsions as a base paint for glaze work, stenciling, découpage, and mounting boards. Use acrylic gesso primer for projects where a smooth surface is required, such as for paintings or for gilding. If using acrylic gesso primer, first seal the board with one coat of undiluted acrylic matte varnish. The method for base painting is the same for both acrylic gesso primers and matte emulsions.

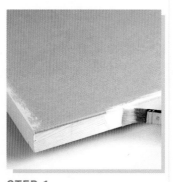

STEP 1

Use a 1 in. (2.5 cm) artist's fitch, glider, or decorator's brush to paint the battened sides.

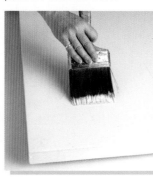

STEP 2

Use a 4 in. (10 cm) decorator's brush to paint the top surface of the board. First lay on the paint in crisscross strokes, and then use long, smooth strokes through the length of the board to brush out any paintbrush ridges, aiming for as smooth a surface as possible. Work a section at a time if you are painting a large board.

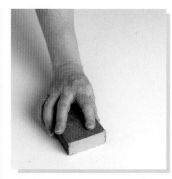

STEP 3

Allow to dry thoroughly. Then use a sanding block or medium-grade sandpaper to sand over the whole surface of the board.

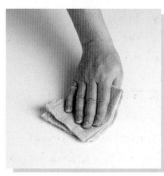

STEP 4

Remove all traces of dust using a tack rag, which has a sticky texture designed for picking up dust and small particles.

STEP 5

Apply a second coat of primer or emulsion in the same way, brushing out as smoothly as possible.

STEP 6

Finally, seal and protect the surface with one coat of matte acrylic varnish applied as smoothly as possible in long, even strokes.

STRETCHING A CANVAS

Canvas is an ideal surface for painting onto with artist's acrylic or oil paints. You can also stencil successfully onto canvas using spray paints, as in the Wild Rose Stencil project on page 98. To prepare your own canvas, you will need to purchase stretchers and wedges as described in the table on page 8. You can also purchase ready-made preprimed canvases from most art suppliers if you prefer to use these.

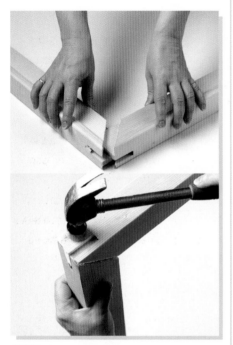

STEP 1
Line up the stretchers so that the corners slot into each other. Use a hammer or mallet to knock the corners together until they fit tightly in a right angle with no gaps.

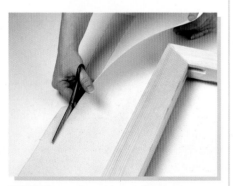

STEP 2
Lay your preprimed canvas or plain cotton duck face down flat on a table, and place the made-up frame on top of the canvas. Cut the canvas all the way around the frame about 6 in. (15 cm) from the edge to allow the canvas to be wrapped around the frame to the back for stapling.

STEP 3
Lay the cut canvas face down on the table, and place the frame on top of it positioned square to the canvas. On one of the long sides of the frame, pull the canvas around to the back and secure it to the frame using a staple gun. Fix the first staple in the middle and then work outward, placing the staples at about 3 in. (8 cm) intervals but leaving the corners unstapled.

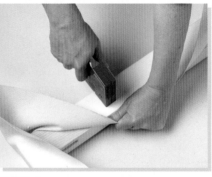

STEP 4
Pull the canvas on the opposite side around to the back of the frame. Stretch it as tightly as possible and fix the staples along this side in the same order as the first side. Repeat this process on the adjacent sides, pulling the canvas as tightly as possible. Go around the frame pulling and stapling in between the first round of staples to tighten the canvas further.

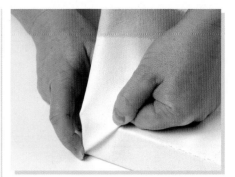

STEP 5
To stretch and finish the corners, gather the canvas together into a fold and pull it firmly up and over each corner. Then fold it back over itself and staple. Cut off excess fabric as required.

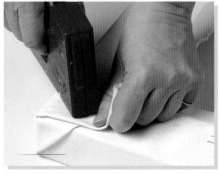

STEP 6
The canvas should be stretched like a drum and should "bounce" when you tap it. If it is still a little slack, use a hammer to insert the stretcher wedges into the corners to stretch the canvas on the frame further.

If you have used plain cotton duck for your canvas, prime the canvas with two coats of white alkyd primer using smooth strokes. Paint the sides of the canvas, too.

Hammer stretcher wedges into the corners to stretch the canvas.

PREPARING WALL SURFACES

Many of the projects in this book will work well if applied directly to a wall surface. The only disadvantage is that the feature is permanent and cannot be hung elsewhere or kept for posterity. Painted walls are suitable for painting, stenciling, découpage, and glaze work.

It is important to create as smooth a wall surface as possible. Choose a wall area that is flat and even. Rout out cracks and holes with a wallpaper scraper or blade and then dampen the area and fill with interior filler, leaving a slightly raised surface. When thoroughly dry, sand the area with medium-grade sandpaper and wipe with a damp cloth before priming.

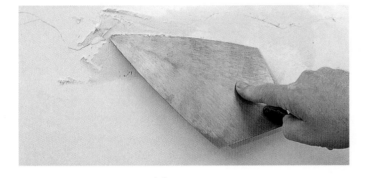

If the area is to be painted a different base color to the rest of the wall, use 2 in. (5 cm) painting tape to mask off the area to be painted, pressing down the edges of the tape firmly. Use a spirit level to ensure the taped edges are straight and then use a fitch brush to varnish over the edges of the tape to prevent paint bleeding under it. Allow to dry.

Paint the area with acrylic gesso primer or matte emulsion following steps 3 to 6 of "Painting Battened Boards" on page 9. Seal the area with one coat of acrylic matte varnish. Then remove the tape and leave to dry. You can apply fresh tape if you are applying glaze work to the area. It is better not to leave tape on for long as it becomes tacky and difficult to remove.

FABRIC PANELS FOR HANGING

Fabrics are used in a number of projects in this book. Most require only cutting and measuring or pattern transfer, which are explained in the individual projects and in "Textile Techniques" on page 22. To create panels for printing or painting, follow these guidelines. Sewing is preferable for a long-term finish, but iron-on hemming tape can also be used.

Cut the fabric to the required size, adding 16 in. (40 cm) to the length for turning the top and bottom and 4 in. (10 cm) for turning both sides.

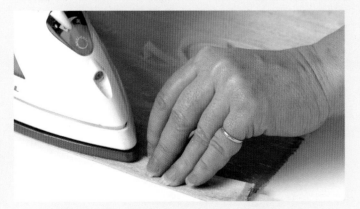

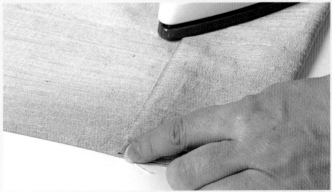

To make up the panel, first turn the sides in by 1/2 in. (1.5 cm) and press. Repeat this turn again by 1/2 in. (1.5 cm) and press. Insert iron-on hemming tape into the fold and press with a hot iron, or pin and then sew the side seams on a sewing machine using appropriately colored thread.

To create the top and bottom hems, fold the top edge over by 1/2 in. (1.5 cm) and press. Fold the fabric over again, creating a fold wide enough for your chosen curtain pole to pass through. Use the iron-on hemming tape to secure, ensuring the sides are left open. Repeat this for the bottom hem.

TECHNIQUES

A wide range of techniques is used to create the stunning wall art pieces shown in the step-by-step projects. Beginners, skilled artists, craft workers, and printmakers will all find something here. The techniques include drawing, painting, stenciling, lino printing, fabric printing, decorative glaze work, gilding, découpage, textile collage, stretched fabrics, and photography.

DRAWING TECHNIQUES

Drawing is a fundamental tool in the visual arts, used extensively in fine art, illustration, decorative work, and design. This is why it is such an important preparatory tool and why good design has good draftsmanship at its core.

The most successful way to learn to draw is to work by observation—that is to draw with the actual subject in front of you. In essence, drawing could be described as a process of "learning to look," and allows you to develop an in-depth understanding of a subject. Practice by first drawing small objects around you and gradually move on to more complex

subjects. Working from the real thing helps to create depth and dimension in your drawing. Photographs can be useful for reference, but most drawings executed just by studying photos tend to be flat and lacking in dimension.

Tonal drawing

Drawing aims to capture the shape and form of an object by showing how it is affected by light, emphasizing the light and dark areas of the object. This is done by making stronger marks or areas of shading and creating a scale of marks and shading

that reflect the same light and dark scale of the object being drawn. This is known as tonal drawing. Tonal study is also fundamental to painting, so tonal drawing is also excellent preparation for being able to reproduce the effect of light and dark in color.

Pattern and texture

As well as the light and dark aspects of a subject, there are also the details of different patterns and textures that make up its characteristics. These can be in the close-up details of one object, the collective pattern that a group of objects makes, the shapes made by the spaces between objects, or even the details of a landscape. Drawings that just focus on pattern and texture usually take the form of linear drawings, where the

mark-making process is of lines, individual marks, and outlines rather than blocks of shading. Felt-tip pens, ballpoint pens, and pen and ink are all good media for this type of drawing.

Mark-making

A wide variety of materials is available for drawing, and different materials will aid different types of drawing. Pencil, charcoal, pastel, and chalks are excellent for tonal work. Pen and ink, felt-tip pens, and ballpoint pens are good for linear work depicting pattern and texture. Each drawing tool will have a range of mark-making abilities when used with different intensities, angles, and pressures. Experiment with the range of marks your chosen tool can make.

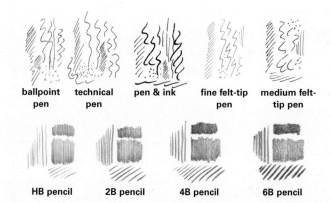

| ballpoint pen | technical pen | pen & ink | fine felt-tip pen | medium felt-tip pen |
| HB pencil | 2B pencil | 4B pencil | 6B pencil | |

Composition

Drawing is an important compositional tool. A sketch or study of a subject can be of great assistance when working on a larger piece or when working up the structure and placement of objects, the perspective of a piece, and what aspects should sit at the different depths of the picture plane. Composition covers such aspects as how the objects fill the space, the gaps between objects, and the perspective of objects.

Good composition draws the eye in and around the picture

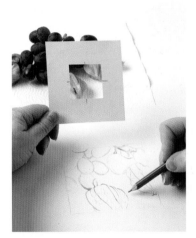

plane. It is useful to make small compositional studies before tackling a main piece. One method for creating good composition is to make and use a small viewfinder (see page 65). Move the viewfinder to alter the size and amount of space the subject takes to fill the frame. Then translate the best view onto your paper.

Perspective and the picture plane

Perspective is the representation of distance and space through a picture. It is depicted by the decreasing size and detail of objects as they become more distant, which also includes receding focus and intensity of color. Receding perspective happens through the different plains of a picture, which translates as the foreground, mid-ground, and distance. A figurative or representational piece will reflect these levels, but perspective is not necessarily shown in decorative art.

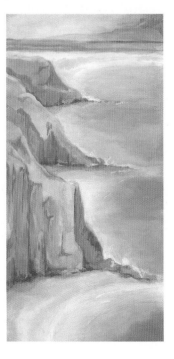

SCALING UP AND TRANSFERRING DESIGNS

Having selected a sketch or study for your artwork, you will need to enlarge it to the scale of your wall art. You can take your design to a photocopying store that has the machine to make large copies and ask them to enlarge the drawing to your specified dimensions. You can then transfer it to your board using wax-free transfer paper (see below).

Alternatively, you can scale up by eye, simply by plotting out a grid on the sketch and an enlarged version of the grid on the board. Then plot each section of the sketch onto the large grid. Artist's enlargers can also be purchased. These are electrical devices that project enlarged images or objects onto wall surfaces to be traced over—useful for some of the projects in this book.

Transferring your design

Place wax-free transfer paper face down on the surface to be drawn onto, and then place the drawing on top of it and secure with masking tape. Use an HB pencil or ballpoint pen to draw over the outlines of your drawing to transfer them. Move the transfer paper as necessary under the main drawing until you have transferred the whole drawing.

Scaling up your design

Draw a grid on your original drawing or sketch, and then draw the same grid on a larger scale onto the surface you are going to work on. The grid can have as many or as few sections as you require. A simpler piece will need fewer divisions than a more complex design, where a greater number of divided grid sections will help you enlarge the detail accurately.

PAINTING TECHNIQUES

There are many forms of painting and ways to approach painting. The painting projects in this book cover both fine art and illustrative styles using representational and abstract approaches. This means there is a project to suit all tastes. Representational art depicts objects in a realistic way; objects and places are all recognizable as such. Abstract is the term loosely applied to painting that represents the subject by shapes and patterns, which can also include blown-up details and close-ups.

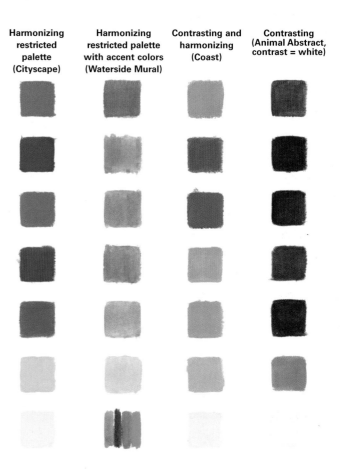

| Harmonizing restricted palette (Cityscape) | Harmonizing restricted palette with accent colors (Waterside Mural) | Contrasting and harmonizing (Coast) | Contrasting (Animal Abstract, contrast = white) |

Observation and imagination

Working from observation is one of the best ways to get to know a subject. Observational skills are at the core of representational painting. Even if you cannot work directly from the subject on a large scale, observational pencil or watercolor sketches are a good starting point for creating larger pieces.

Working purely from imagination is rare as so much in art is referenced to our experiences, other art, history, nature, and all aspects of reality. However, imagination is a talent that can make a picture come alive. An imaginative interpretation of a subject, imaginative use of color, and imaginative composition can all take a painting from the ordinary to the extraordinary.

Local and tonal color

The color journey starts with getting to know how color works and the relationship between different colors and different types of color. The most important tool in this is understanding the use of local and tonal color. Tonal color describes color affected by light, and shows a spectrum of light and dark shades within one hue. It is used widely in representational painting. Local color is the actual flat color of an object and is used mainly in design and decorative work.

Tonal color **Local color**

Color palettes

A good way to start working with color is to use a restricted palette, where you put only a limited number of colors onto your palette for mixing and painting. This helps you to get to know the properties of a color, its intensity, and its relationship with other colors. Paintings worked with a restricted palette (or tight palette) tend to have a good cohesive sense. In contrast, working with the whole spectrum of colors can be daunting and can cause too much color variation within a picture. Most of the painting projects here use restricted palettes.

One type of restricted palette is the harmonizing palette, where the colors used are close to each other on the color wheel or have similar root colors. Examples in this book include the blues, grays, and lavenders used in the Cityscape project (page 36) and the warm earthy browns of the Abstract Shell Detail (page 64). Another type is the contrasting-color palette. This palette can be made up of two harmonizing colors and one contrasting color, such as the pale blue, gray, and sand colors of the Coast painting (page 68). It can also be made up of strongly contrasting colors, such as the warm browns and contrasting white of the Animal Abstract project (page 34).

Working with color is a personal journey. Other people's ideas and basic color know-how can help. Overall, though, it is something you discover yourself through different experiments and approaches. The painting projects in this book will introduce painting and the use of color in specific ways and more experienced painters may discover new angles.

Mixing colors

A good basic color palette should include the following colors: warm and cool primaries—lemon yellow, cadmium yellow, alizarin crimson, vermilion, ultramarine, and cerulean; warm and cool earth colors— raw umber, burnt umber, raw sienna, and burnt sienna. You will also need titanium white. These colors will allow you to mix all colors and shades, including black. It is better to mix your own black rather than to use it straight from the tube as it tends to deaden other colors. To mix grays, use a blue and vermilion or a blue and an earth color with a little white to create warm and cold grays according to what is needed. Similarly, paintings tend to be fresher and richer if you mix your own green shades as greens from the tube can also have an overpowering and deadening effect, especially viridian.

The ability to mix colors comes with a little practice and knowledge of how different colors and pigments combine and react together. It is worthwhile learning how to use and mix warm and cold colors together. This forms the basis of most color relationships and allows you to mix both clean, vibrant colors and more muted shades for tonal variations.

Basic color palette

Lemon yellow / Cadmium yellow

Alizarin crimson / Vermilion

Ultramarine / Cerulean

Raw umber / Burnt umber

Raw sienna / Burnt sienna

Mixing blacks and grays

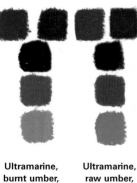

Ultramarine, burnt umber, and varying amounts of white.

Ultramarine, raw umber, and varying amounts of white.

Mixing muddy grays

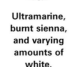

Cerulean, burnt sienna, and varying amounts of white.

Ultramarine, burnt sienna, and varying amounts of white.

Depth of field and color in perspective

Colors change their nature and intensity according to where in the picture plane they are. This is known as advancing and receding color. Colors in the foreground of a painting are naturally stronger and brighter than colors in the distance, which are paler and less intense. Depth of field is shown by the use of color and the kinds of mark-making used to depict colors and objects at different distances.

Mark-making and brushwork

How you apply paint and the kinds of brushstrokes and marks you make varies with different brushes. Experiment with different artist's and decorative brushes to discover the kinds of marks they make. The painting projects in this book make use of artist's brushes, such as sable and fitch brushes, and decorative brushes, such as gliders and softeners. Both types of brush have a stiff bristle and soft bristle version, and the main difference between them is size. It is useful to be able to switch between the two as you change scale in your work and as you move from looser, larger strokes to small, detailed marks.

Paint viscosity

Paint can be applied in different ways to create different effects. The effect created by applying a wash of thin paint is very different than the feel and look of thick, opaque color. Transparent glazes have depth and luminosity, whereas opaque colors are solid and flat. Both are useful, depending on the effect you are trying to create. As you paint, you will start to gain experience of what paint does when it is mixed thinly or thickly and gradually learn how to manipulate it to create the different effects that you want.

Types of paint

Different types of paints have different viscosities, different color intensities, and different temperaments when applied. Watercolors and artist's gouache are very different in makeup and temperament than artist's acrylics, and artist's oils are again very different than any water-based paint. The different media suit different types of painting as well as different people. You should work with each to find your own preference.

GLAZE WORK

Glaze work is used extensively throughout the projects to create "grounds" that have a broken color effect and bring depth and dimension to decorative and painting projects. Use glazes as washes for painted projects to add depth and cohesion to the overall effect or to sections of a painting.

GLAZE RECIPE

This basic recipe is used for all of the glaze work techniques in the projects. It is tinted with different universal tint colorants to create the range of colors used. Tint colors are listed in the individual projects.

To make 1 pint (500 ml) of water-based glaze
☐ 6½ fl oz. (200 ml) acrylic scumble glaze
☐ 6½ fl oz. (200 ml) acrylic matte varnish
☐ 3¼ fl oz. (100 ml) water
☐ Universal tint colorants to tint to required color

Most projects will use about 1 pint (500 ml) of glaze. Keep the glaze in a sealed container or cover with plastic wrap while not in use to prevent a skin from forming. This glaze recipe uses a portion of acrylic matte varnish in order to speed up drying times and to allow for the buildup of different-colored glazes when overglazing. The varnish also gives the glaze work added protection. If you are planning to scale up any of the projects to work on larger wall areas, change the quantities to 10 fl oz. (300 ml) acrylic scumble glaze, 3¼ fl oz. (100 ml) acrylic matte varnish, and 6½ fl oz. (200 ml) water. Allow longer drying times before applying successive layers of glaze or sealing with varnish.

Tinting and coloring glazes

Using universal tint colorants—a liquid tinting agent—is the best way to color water-based glazes. The liquid colorant disperses easily into the glaze and is less prone to streaking than are pure powder pigments. To tint the glaze, add each color to the glaze mixture a drop at a time, stirring thoroughly.

Test glaze color strength before applying. As a general guideline to color strength, use two drops for pale colors, five or six drops for medium-strength colors, and up to ten drops for intense colors.

STEP 1
To tint the glaze, you will need the glaze mixture in a bowl, the universal tint colorants, and a brush or spoon for mixing.

STEP 2
Add the universal tint colorant to the glaze one or two drops at a time.

STEP 3
Stir thoroughly until all the color is fully dispersed throughout the glaze.

STEP 4
The finished glaze color should have no streaks or variations. Add more colorant as necessary, always stirring thoroughly.

GLAZING EQUIPMENT

Acrylic scumble glaze; acrylic matte varnish; universal tinters in white, black, ultramarine, cobalt, alizarin crimson, vermilion, yellow; yellow ocher, burnt sienna, burnt umber, raw umber; mixing containers; fitch brush for mixing; decorator's sponge; natural sea sponge; hog hair softener; badger softener; stencil brush, washing up brush for spattering; 4 in. (10 cm) synthetic decorator's brush; glider brushes

Applying glazes

Glazes can be applied in different ways to create varying effects. The basic principle is to apply the glaze, usually with a sponge or brush, and then immediately soften it with a softening brush, which creates a soft mottled or veined effect. For decorative grounds, always apply glazes to surfaces sealed with acrylic matte varnish (see page 9) as an unvarnished surface is too absorbent and a streaky or blotchy finish will result.

Softening and antiquing effects

Once a decorative groundwork has dried, you can apply a tinted varnish to soften the effect or make a color lighter or darker. To apply tinted varnish, use a wide synthetic decorator's brush and either brush it out in long, smooth strokes or use a hog hair softener to soften the brush strokes. Tinted varnish techniques are used in Orchid Découpage (page 92), Abstract Shell Detail (page 64), and Starscape (page 112).

APPLYING GLAZES FOR COLOR WASH EFFECTS

This technique is used in several projects, including Botanical Mural (page 44), Blossom Bough (page 94), and Butterfly Sky (page 108).

STEP 1
Pour a puddle of glaze approximately 2 in. (5 cm) diameter onto a decorator's sponge.

STEP 2
Apply this to the wall or board in large figure eight sweeping motions, circling around until no gaps are left uncovered.

STEP 3
Use a hog hair softener and sweep it over the glaze in large crisscross strokes to soften and even out the glaze. Keep the movement of the brush fast and light, working repeatedly in different directions.

APPLYING GLAZE FOR SPONGED EFFECTS

This technique is used in several projects, including Botanical Mural (page 44), Orchid Découpage (page 92), and Butterfly Sky (page 108).

STEP 1
Pour a dessert spoon of glaze onto a natural sea sponge, and squeeze it a few times to spread the glaze throughout the sponge.

STEP 2
Apply the sponge to the wall or board in a light dabbing motion.

STEP 3
Use a hog hair softener or badger softener to dust over the glaze lightly in soft crisscross strokes to soften and even out the glaze. Keep the movement of the brush fast and light, working repeatedly in different directions.

NOTE
Most of the board sizes used in the projects will take two sponge applications (steps 1 and 2), which can be softened at the same time (step 3). If you are working on a larger wall space, apply glaze and soften a section at a time or ideally work with two people, one applying glaze and one softening.

ANTIQUING EFFECTS

This method can be applied to nearly finished paintings to achieve an aged effect.

STEP 1
Apply an acrylic matte varnish tinted with a few drops of raw umber tint colorant to blend the underlying pattern and add an antiqued or aged patina.

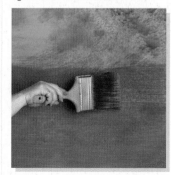

STEP 2
Soften the varnish with a hog hair softener, using broad, crisscross strokes.

SOFTENING GLAZES

Apply an acrylic matte varnish tinted with a little white universal tint colorant to lighten and soften underlying glaze work.

VARIATION

Apply varnish tinted with the relevant color to give the underlying glaze a greater cohesion, or simply to darken or lighten the effect as desired.

PRINTMAKING

Printmaking in its different forms is a fantastic technique for creating individual decorative pieces for the home. Images can be worked on a large scale or repeated in blocks or columns to create impressive features and wall art. The projects here utilize stenciling for working on gilded surfaces, silk panels, canvas, and glaze work. There is also a lino printing project, which is covered fully on pages 48–53.

Stenciling

Stenciling is a simple but extremely effective way of applying a pattern to different surfaces. The benefit of stenciling is that although the actual design work has been done for you, the way the stencil is positioned and the materials used for printing create an individual artwork. All of the stencils used for the projects can be purchased from the author's website www.hennydonovanmotif.co.uk

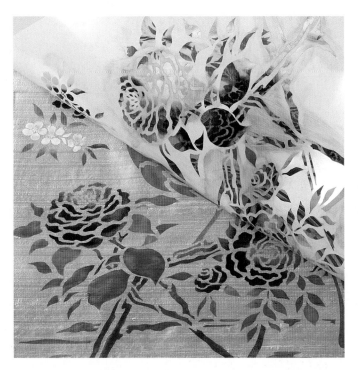

Stencil surfaces

Absorbent surfaces such as fabric are easier to stencil onto than shiny surfaces. Their absorbency means that paint is less likely to seep under the stencil, so it is easier to achieve clean, crisp edges.

 Shiny surfaces are much harder to stencil onto because the paint will easily bleed under the stencil. On wall surfaces and boards, stencil onto a surface painted with matte emulsion, which is more absorbent than gloss surfaces. If you cannot change from gloss to matte, or if you are stenciling onto shiny ceramic surfaces, stencil very lightly with a nearly dry sponge. Build up opacity with successive layers of color.

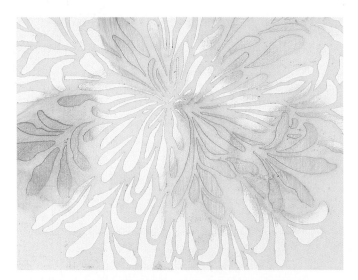

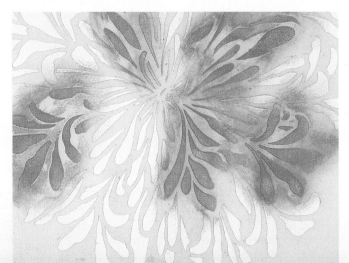

STENCILING EQUIPMENT

Stencil paints; fabric paints, spray paints; repositionable spray adhesive; masking tape; stencil sponges; stencil rollers; divided palette, ceramic plate; kitchen towel

TIPS FOR SUCCESSFUL STENCILING
Follow the guidelines below to achieve a good stencil print.

☐ Always use a good repositionable spray adhesive to stick the stencil to the surface. Spray an even coat over the whole of the reverse side of the stencil, making sure that the adhesive is covering fine, intricate areas.

☐ Stick the stencil down securely to the surface, smoothing your hand over the whole of the design to ensure that all bridges and intricate areas are stuck down fully.

☐ Stencil sponges and rollers produce the best results. Brushes tend to be slow and cumbersome for stenciling.

☐ Stencil sponges are good for creating three-dimensional effects and for stenciling intricate designs and working paint into small recesses. Stencil rollers are ideal for stenciling larger surface areas.

☐ Dip the stencil sponge into the paint and dab off excess paint onto a piece of paper towel. This means you can stencil with a nearly dry sponge, which helps to prevent bleeding. If too much paint is applied to the stencil, it will seep under the cut-out shapes.

☐ Dip stencil rollers into the paint and then roll out on a plate or ceramic tile to spread the paint over the roller before rolling it over the stencil. Repeat to build up evenness and opacity.

☐ Overstencil the edges of individual cut-out shapes to create three-dimensional effects.

☐ Spray paints can be used for stenciling and are particularly good where it is hard to secure the stencil to the surface firmly (such as a taut canvas) or on surfaces that are particularly prone to bleeding if wet paint is used, such as glass or ceramic.

Lino printing
In lino printing, ink is applied to the surface of a piece of lino that has had parts of the surface removed to produce an image. Paper is laid on top and pressure applied to transfer the inked image across.

To make a bench hook for lino cutting
A bench hook is an essential piece of safety equipment for holding lino securely while applying pressure during cutting.

Glue and pin one 14 in. (36 cm) length of 2 x 1 in. (5 x 2.5 cm) pine batten onto one edge of a 14 in. (36 cm) square MDF board. Allow to dry.

Glue and pin a second length of wood onto the opposite reverse side of the MDF board.

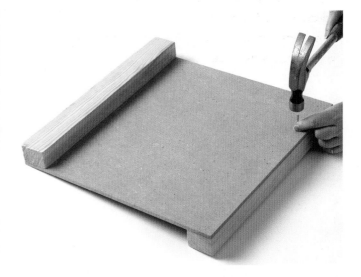

This simple but effective board hooks onto the tabletop for working. It serves as an edge to cut the lino against, which prevents the lino from slipping while cutting.

LINO PRINTING EQUIPMENT

Bench hook; lino; lino cutting tools; white oil pencil; lino printing inks; rubber lino roller; small foam roller; inking up surface or palette; smooth cartridge paper or printing paper

GILDING

Gilded surfaces make good decorative backgrounds for both painting and stenciling. Using Dutch metal transfer is straightforward even for those with no previous gilding experience. The gilded surface should always be sealed with either white polish or button polish shellac and ultimately varnished to prevent the tarnishing effects of oxidization. The shellac provides a surface for paint, which would separate if applied directly to the metal surface.

GILDING EQUIPMENT

Gold or silver Dutch metal transfer; acrylic gilding size; gilding mop; 1 in. (2.5 cm) fitch or glider; 3 in. (7.5 cm) glider; white polish shellac or button polish shellac; methylated spirits; fine wire wool

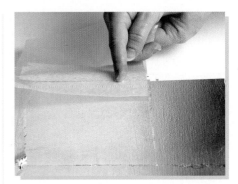

STEP 4
Apply the next sheet in the same way, immediately to the right of the first. Continue sticking each sheet down, butting each sheet up to the last. Once the first row of gilded sheets is complete, continue the process with the second row, lining up each sheet directly underneath each square of the first row to create a neat grid of metallic squares.

GILDING TECHNIQUES
To gild a flat surface with metal transfer, follow these basic guidelines. Metal transfer comes in aluminum, gold, copper and some specialist metal effect finishes as well—choose a color that will suit your project and room scheme.

STEP 2
Apply acrylic gilding size in 12 in. (30 cm) sections. Leave for five minutes or until the size becomes tacky.

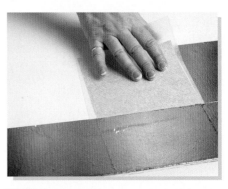

STEP 5
Continue to apply rows of sheets, working in sections, until the whole area is covered. Repair any gaps between squares by pressing small strips of transfer over them while the gilding size is still tacky.

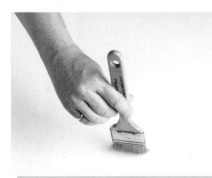

STEP 1
Apply one coat of white polish shellac with a 3 in. (7.5 cm) glider or varnish brush. Use long, smooth strokes, making sure that you do not overbrush the same area twice as the shellac dries rapidly and becomes sticky and patchy if overbrushed. Allow to dry.

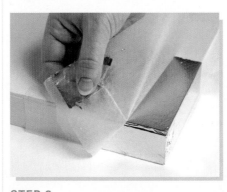

STEP 3
Starting in the top left corner, lay down the first sheet of Dutch metal transfer and smooth with your fingers to ensure it is fully stuck down. Carefully peel away the backing sheet to reveal the metal below.

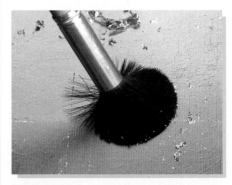

STEP 6
Leave the gilding to dry completely. Use a soft gilder's mop to brush away lightly the loose bits of metal transfer, working in circular movements and backward and forward until the excess transfer becomes loose. Wipe away the loose metal castings.

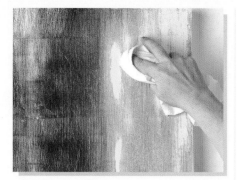

STEP 7

For a distressed effect, use fine wire wool or sandpaper to rub the metal away from some sections such as corners and edges. Rub lightly until the metal transfer starts to break away. Then use a damp cloth to rub away the gold until some of the underlying paintwork shows through.

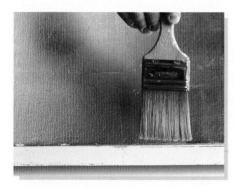

STEP 8

To seal the gilded area, apply a coat of white polish shellac, smoothly gliding the shellac over the gilded surface, taking care not to overbrush any one area. Use button polish shellac if you wish to enhance the antiqued effect further. Allow to dry overnight. The shellac turns milky as it dries but will become clear when dry.

STEP 9

Apply one protective coat of acrylic gloss varnish. Leave to dry completely.

DÉCOUPAGE

Découpage has a long history as a popular decorative technique. It can also be used as a modern application with up-to-date images. It was traditionally used on household accessories. It is used in this book to create simple and attractive wall art, which can be applied to a battened board or directly to a prepared wall surface.

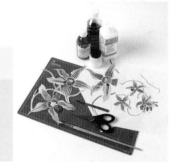

DÉCOUPAGE EQUIPMENT

Images for cutting; PVA glue; scalpel or craft knife; scissors; cutting mat; fitch brush for gluing; white polish shellac for sealing; acrylic matte varnish

DÉCOUPAGE TECHNIQUES

Modern découpage tends to be applied sparsely, with the spaces between images being just as important as the pattern of images itself. Single motifs repeated randomly or in sequence work well. If you are using images created from computer printouts, the colored ink can smear easily. Seal the images with white polish shellac either before cutting out or once they have been stuck down.

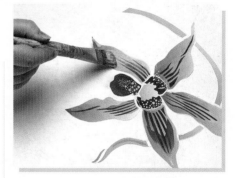

STEP 2

Brush PVA glue onto the back of a motif so that it is covered evenly. Then carefully lift the motif and stick it onto the prepared surface. Use a fitch brush to brush out wrinkles.

STEP 3

Repeat this process until the piece is complete. Allow to dry fully. Seal with either white polish shellac or more PVA glue, and varnish with acrylic matte varnish.

STEP 1

Cut out your chosen images with a scalpel, cutting as close to the image as possible. Cut more images than you are likely to need so that you have a selection to work with.

FINISHING, MOUNTING, AND FRAMING

Finishing your artwork properly can give it a truly professional appearance. See below for advice as to whether varnishing is necessary to seal your work. Follow the step-by-step instructions for trimming and mounting finished prints and drawings. Framing is also discussed, including techniques for framing a battened board.

FINISHING

Your wall art can be finished with a coat of varnish to seal it and protect it from air moisture and water or food splashes. However, varnish can flatten the natural textures and different reflective qualities of paint. The need for varnishing will be largely determined by where a piece is going to hang. Follow the guidelines given here to decide whether varnishing is necessary.

MATERIALS AND EQUIPMENT FOR FINISHING, MOUNTING, AND FRAMING

Finishing	Acrylic varnish in matte, eggshell, or gloss; picture varnish; spray matte varnish; white polish shellac; artist's fixative spray
Mounting	Permanent spray adhesive; scalpel knife; cutting mat; metal ruler; newspaper; tissue
Framing	Wooden surround battens; made-up frame; window mounts; scalpel knife; cutting mat; metal ruler; hammer; wood glue; ¾ in. (2 cm) or 1 in. (2.5 cm) panel pins; plastic wood filler; sandpaper; acrylic matte or eggshell varnish; wax for wood

Paintings

Most of the painting projects in this book have been applied to boards that either have been base painted with emulsion or gesso primer and sealed with acrylic matte varnish or have a glaze background (the glaze recipe includes matte varnish). For these projects, a final coat of varnish is not necessary.

A painting executed in artist's acrylics, acrylic scumble glazes, and other acrylic mediums should not need varnishing unless it is going to be hung in a kitchen or bathroom. A painting in gouache or watercolor can be sealed and protected with white polish shellac and then a coat of acrylic matte varnish or a spray matte varnish. Alternatively, watercolors and gouache can be protected by glass or Perspex in frames.

Drawings

Finished pastel and charcoal drawings can be fixed with artist's fixative spray, which offers some protection from smudging. The same spray can be applied to pencil drawings. You can also use a light application of hair spray, which does not yellow the paper as some fixative sprays do.

Spray varnishes can be used on drawings if protection is needed. Glass coverings are most suitable for drawings that are to be displayed in bathrooms or kitchens.

Stencil work

Stencil projects on boards should not need varnishing, especially as these are usually executed on decorative glaze grounds or matte emulsion sealed with acrylic matte varnish before stenciling. The same applies to stenciling on varnished gilded surfaces. However, if the surface has not previously been sealed with varnish, you may need to add a final coat of varnish if the piece is to hang in a position that warrants it.

MOUNTING FINISHED WORK

Some of the projects are drawn or printed on paper, including photographic prints, which are then mounted onto preprepared battened boards. Details of dimensions for all battened boards are given in each project.

HOW TO MOUNT

Follow these steps for mounting drawings, prints, photographs, and stencil prints onto boards.

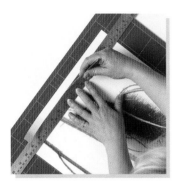

STEP 1
Trim the artwork to the exact size to fit the board using a scalpel or sharp craft knife.

STEP 3
Position the artwork flush with the top of the board and stick it down from top to bottom. For drawings and photographs, lay a sheet of tissue paper over the image before smoothing it over with a soft dry cloth.

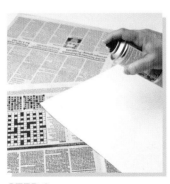

STEP 2
Lay the trimmed artwork face down on several sheets of newspaper or tissue. Holding the spray nozzle at a distance of 8 in. (20 cm), spray a permanent photo adhesive from left to right across the back of the photo. Then spray up and down across the back of the photo.

STEP 4
For lino or stencil prints, line the print up with the block it is to be mounted on. From the top to the bottom of the print, push the print down onto the block, pressing and easing it down firmly until it lies flat.

FRAMING

Many of the projects have been created on battened boards. Some of these pieces, particularly paintings on single boards, may benefit from a wooden surround. This is not necessary for groups of boards, or pieces where the artwork wraps around the sides of the board.

As an alternative to working on boards, you can work on paper or card and frame your artwork. This is a good solution for work that is to be hung in kitchen or bathroom areas.

Framed pictures benefit from a window mount. This is thick cardboard that fits over the picture like a window frame. To frame, trim the artwork so that it fits into the frame but is larger than the mount. Place the mount over the artwork, secure at the back with masking tape, and place in the frame. Use masking tape to seal the opening at the back.

FRAMING
BATTENED BOARDS

STEP 1
The wood for the surround can be softwood (usually pine) or a hardwood, and it should cover the sides of the board. The depth of the surround can be either exactly matched to the depth of the board, or slightly deeper if an overhang is desired.

STEP 2
Apply any treatment to the wood prior to fixing it onto the board. First sand it smooth. To wax it, use beeswax polish. To stain it, use a commercial wood stain. For painting, use wood paint or matte emulsion. Alternatively, rub white or ivory paint into the wood for a limed look.

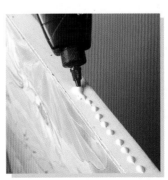

STEP 3
Once the wood has been prepared, squeeze a line of strong wood glue along each side

of the board. Align the wooden surround so that it fits either flush to the front of the board or overhangs the front of the board slightly. Keep the depth of the overhang even.

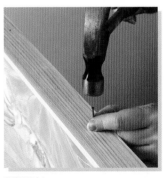

STEP 4
Use a hammer and either ¾ in. (2 cm) or 1 in. (2.5 cm) panel pins (depending on the depth of the wood being used) to pin the wooden surrounds to the sides of the board, making sure that the corners line up squarely.

STEP 5
Let dry for ten minutes, and then use a nail punch and hammer to sink the panel pins about ⅛ in. (3 mm) into the wood. Fill the holes with plastic wood filler. When dry, sand smooth and flush to the rest of the board.

NOTE
Wooden surrounds can be fixed onto canvases in the same way.

THE PROJECTS

The projects are designed around different areas in the home. Themes used for the different projects aim to complement different room settings and to give a diverse range of choices to suit different types of interiors. There are no firm rules as to where different themes should be used, but some subjects are naturally associated with certain rooms. Different themes will suit different people and the way they lay out their homes. Many of the projects can be used in any room—although red peppers may look a little strange in the bedroom or bathroom! Rooms and spaces focused on include halls and stairways; kitchens and conservatories; living rooms, dining areas, and studies; and bathrooms, bedrooms, and children's rooms.

 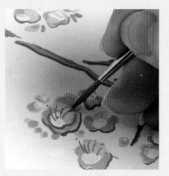

 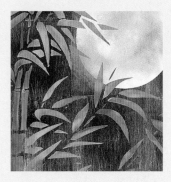

 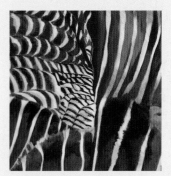 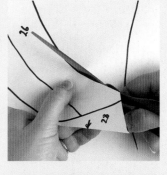

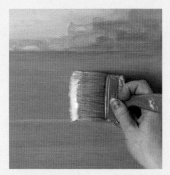 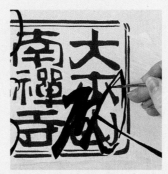

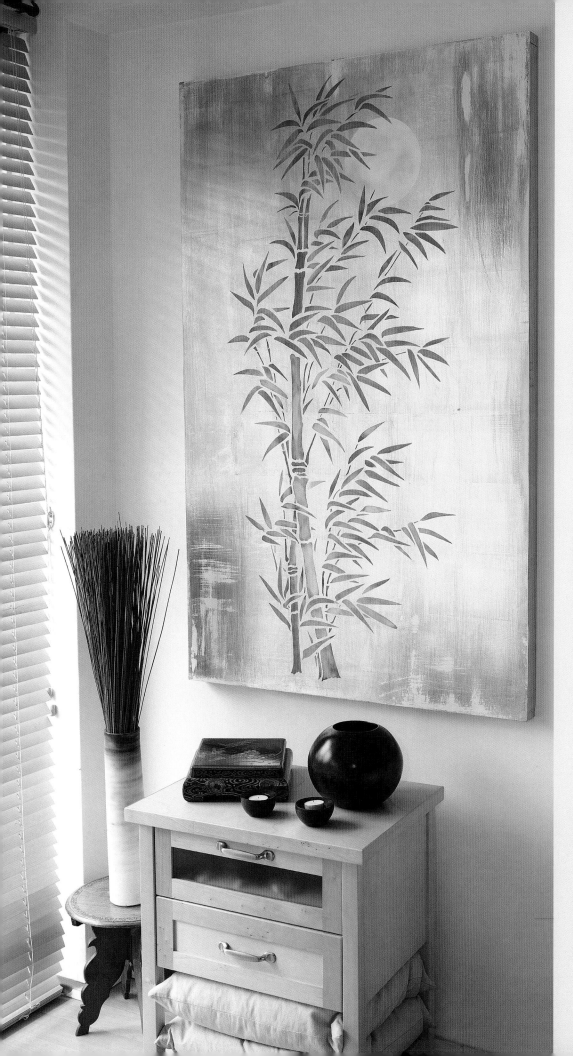

BAMBOO AND MOON

The originality and elegance of this gilded panel, decorated with an oversized bamboo and moon stencil, makes for a piece that will be a treasure for years to come, with its modern interpretation of a classic Eastern theme. This sumptuous panel is ideal as a focal piece in a hallway, stairwell, or large living room.

PREPARATION: Prepare the battened board following the instructions on page 9. Apply a base of two coats of pale cream matte emulsion, sanding between coats to create a smooth surface. Use a tack rag to remove all traces of dust. To prepare the surface for gilding, use a varnish brush to apply one coat of white polish shellac. Work in long strokes, taking care not to over-brush the same area twice, as the shellac dries rapidly and becomes sticky and patchy if over-brushed. Allow to dry completely.

TOOLS & EQUIPMENT

33½ x 53 in.
(85 x 135 cm)

- ❏ ¼ in. (6 mm) MDF board 33½ x 53 in. (85 x 135 cm)
- ❏ 4 x 1¾ in. (4 cm) battens cut to fit board
- ❏ 4 in. (10 cm) synthetic decorator's brush
- ❏ Pale cream matte emulsion (latex)
- ❏ Tack rag
- ❏ White polish shellac
- ❏ Methylated spirits
- ❏ Small varnish brush
- ❏ 5 packs Dutch gold metal transfer—25 x 5½ in. (14 cm) square sheets per pack
- ❏ Acrylic gilding size
- ❏ Fine wire wool or sandpaper
- ❏ Clean damp cloth
- ❏ Gilding mop
- ❏ Acrylic gloss varnish
- ❏ Bamboo and Moon stencil (see Resource Directory), or other similar design
- ❏ Repositionable spray adhesive
- ❏ Spirit level
- ❏ Stencil paints in white, silver, gold, pale and medium sage, mossy greens, and warm mid and dark tone browns
- ❏ Stencil roller
- ❏ Stencil sponges
- ❏ Divided palette

STEP 1
Use a small varnish brush to apply acrylic gilding size to the top section of the board, to a depth of 12 in. (30 cm) across the top and including the sides. Leave for 5 minutes or until the size becomes tacky. Stick the metal transfer onto the sized area, starting in the top left corner. Lay it onto the corner so that enough hangs over the edge to cover the sides. Smooth over the top surface with your fingers to ensure that it is fully stuck down.

STEP 2
Press the transfer down over the sides, working right into the corners. Carefully peel away the backing sheet to reveal the gold below.

STEP 3
Stick the next sheet immediately to the right of the first, again allowing enough overhang for the top edge of the board. Repeat until you come to the other corner, treating that in the same way as the first. You can cut the transfer for the side sections to size before sticking or trim it with a sharp scalpel when in place. Continue this process to create a second row of gold metal transfer, lining each sheet directly underneath the first.

STEP 4

After the second row, apply the next section of size and continue sticking the transfer sheets as before, aligning each sheet under the one above. Repeat this process until the board has been covered. Repair any areas where the transfer has not stuck down, or gaps between squares, by pressing small strips of transfer over them while the size is still tacky (acrylic gilding size has a working time of about 30 minutes).

STEP 6

Leave the board to dry completely for an hour or so, and then use a soft gilding mop to brush away the loose bits of metal transfer. Whisk the brush over the board in a circular motion and backward and forward, working the excess transfer loose. Wipe away all of the loose metal transfer and dust particles from the board and use a vacuum cleaner to remove all loose metal castings from the working area.

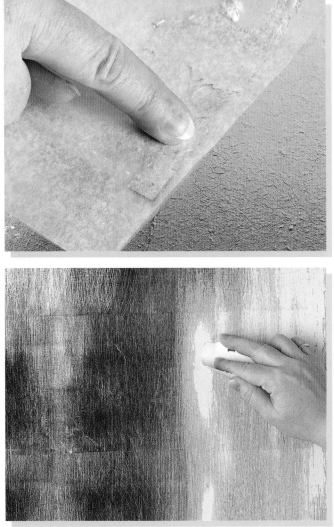

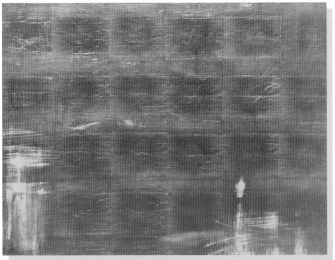

STEP 5

The finished board can be left as it is or distressed for an antiqued effect. To distress, use fine wire wool or sandpaper to rub the transfer away from some areas on the corners, edges, and patches on the front of the board. Rub lightly until the metal transfer starts to break away, then use a damp cloth to rub away the gold until some of the underlying pale cream paint shows. Keep this effect subtle.

STEP 7

Apply a coat of white polish shellac, smoothly gliding it over the surface in sections across the entire length of the board, taking care not to over-brush any one area. Allow this to dry overnight. During the drying process the shellac will turn milky, but it will become clear when it is dry. Apply one protective coat of acrylic gloss varnish and let dry completely.

STEP 8

To stencil the bamboo, apply repositionable spray adhesive to the reverse side of the bottom section of the stencil and stick it to the bottom of the gilded board, using a spirit level to ensure that the stencil is square. Stick down thoroughly. Pour a selection of pale and mossy green and different-toned brown stencil paints into the palette, then use a stencil roller to stencil the pale green over the whole stencil, adding darker tones of green on top.

STEP 10

Peel the stencil carefully away from the gilded surface and position the moon stencil next. Apply spray adhesive to the moon stencil, then either position by eye or by aligning the top section of the bamboo stencil and positioning the moon behind it, so that it will sit behind some of the bamboo leaves. Stencil the moon in white, silver, and gold stencil paints, working first with a roller and then adding metallic mottled highlights with a stencil sponge.

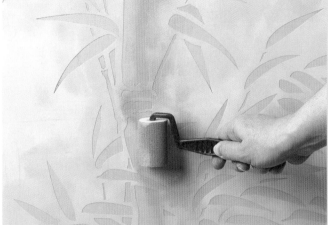

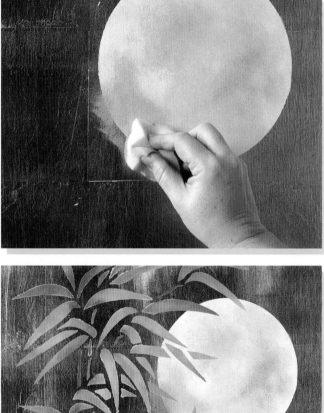

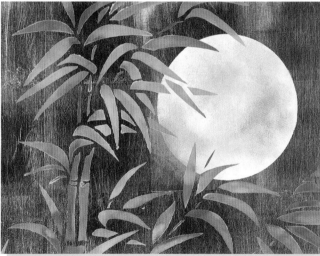

STEP 9

Use a stencil sponge to stencil areas of brown onto the stems and leaves, also stenciling the registration dots in the top corners. Stencil gold highlights to some of the leaves and stalks.

STEP 11

Once the moon has dried, apply adhesive to the reverse side of the top section of the bamboo stencil and stick it into place, lining up the registration dots in the bottom corners with the dots stenciled on the board. Stencil using the same colors as the lower section. Allow to dry thoroughly before hanging. For full effect, hang this in a position where it will pick up different nuances of changing light.

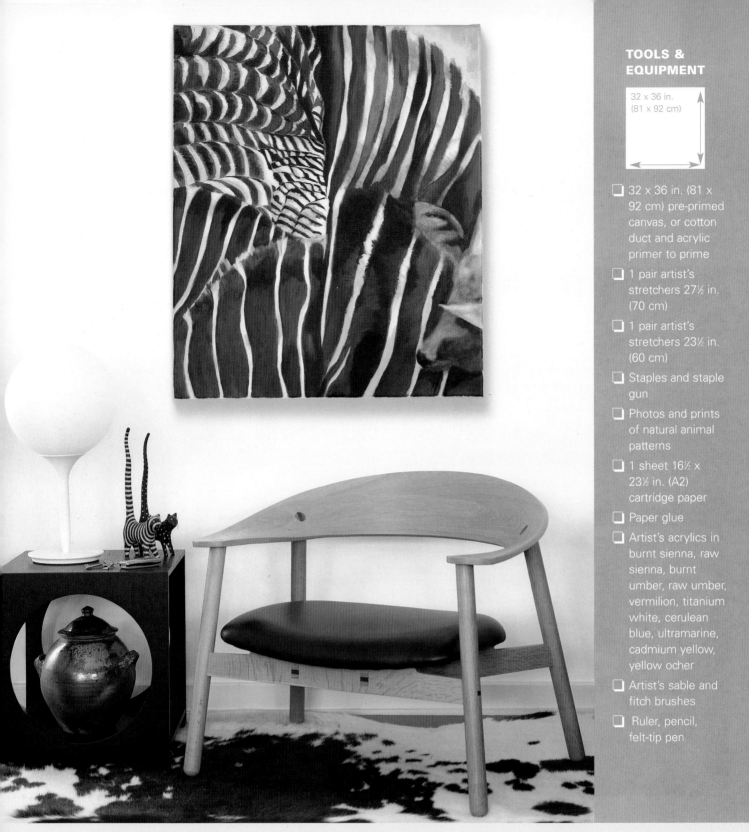

TOOLS & EQUIPMENT

32 x 36 in. (81 x 92 cm)

- ☐ 32 x 36 in. (81 x 92 cm) pre-primed canvas, or cotton duck and acrylic primer to prime
- ☐ 1 pair artist's stretchers 27½ in. (70 cm)
- ☐ 1 pair artist's stretchers 23½ in. (60 cm)
- ☐ Staples and staple gun
- ☐ Photos and prints of natural animal patterns
- ☐ 1 sheet 16½ x 23½ in. (A2) cartridge paper
- ☐ Paper glue
- ☐ Artist's acrylics in burnt sienna, raw sienna, burnt umber, raw umber, vermilion, titanium white, cerulean blue, ultramarine, cadmium yellow, yellow ocher
- ☐ Artist's sable and fitch brushes
- ☐ Ruler, pencil, felt-tip pen

ANIMAL ABSTRACT

This painting takes the striking patterns found in the animal world to create a distinctive piece of artwork. This piece depicts the elegant markings of the shy and retiring bongo, a graceful antelope of the African bush, rarely seen or heard, and the pattern of a falcon's wing, which share similar, beautifully graphic markings. Use this painting to bring warmth and structure to a hall setting.

STEP 1
To design your abstract picture, collect photos and prints of inspiring natural animal patterns. Enlarge close ups of these on a photocopier or computer and printer to an 11 x 8½ in. (A4) format. Then try different arrangements with the selection of patterns.

STEP 2
Choose four images and arrange them so that the shapes and patterns flow together or have a pleasing rhythmic arrangement. Stick these together as a collage onto the large sheet of paper, and then divide the collage into a nine-section grid and mark with a felt-tip pen.

STEP 3
Make up a canvas (see page 10). Divide the canvas into a corresponding nine-section grid, using a ruler and pencil to lightly draw the grid onto the canvas.

STEP 4
Mix a watery solution of burnt sienna and water and use a fine sable brush to lightly paint the outlines of each section onto the canvas in the corresponding grid sections, enlarging the design as you go. Use the same wash to lightly fill the burnt sienna sections of the stripes of the pattern. This helps to avoid confusion that working with stripes can cause.

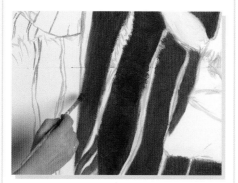

STEP 5
Once the outlining and wash process is complete, mix some burnt sienna, raw sienna, and vermilion to make a rich terra-cotta color. Add enough water to make the paint flow evenly. Use large sable and fitch brushes to fill the burnt umber stripes of the design, observing the varying tones of the picture collage and altering the colors of the paint to match these.

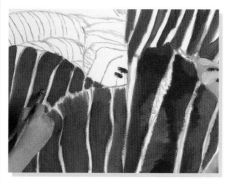

STEP 6
Continue this process, working each section of the canvas in the same way and being as faithful as you can to the subtle color changes in your collage, until each section is filled in.

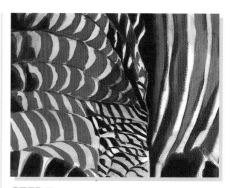

STEP 7
Working section by section, start to add detail and depth to the different stripes and markings, as well as painting in the white stripes with different tones of off-white and cream. Paint in the areas around the edges of the main picture.

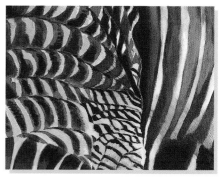

STEP 8
Observe the subtle tonal nuances caused by the effect of light on the colors and add these to the corresponding areas of your painting. Note the different textures of the fur, and add this contrast to your painting, using a range of brushes to create different textural marks.

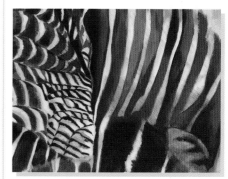

STEP 9
Finally, mix a watery solution of burnt sienna and use it to wash over some areas of the painting. This will add depth to the painting, as well as blending the different aspects of the picture together.

SEE ALSO:
STRETCHING A CANVAS, PAGE 10
PAINTING TECHNIQUES, PAGE 14

CITYSCAPE

This atmospheric cityscape uses a harmonizing palette of blue, purple, and gray to capture the fading light and silhouette of the city's skyline at dusk—just as the city lights start to twinkle across the river water. The style and feeling of this painting is inspired by Whistler's *Nocturne* paintings, and the way he captured the atmosphere of the city at dusk. Of course, 140 years later, our cities are more built up, so this is a modern interpretation with both classic and contemporary architectural silhouettes peppering the skyline. The wide horizontal format is ideal for hallways.

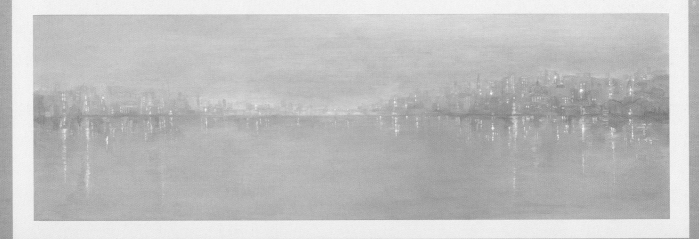

TOOLS & EQUIPMENT

63 x 19¾ in.
(160 x 50 cm)

- ☐ ¼ in. (6 mm) MDF board 63 x 19¾ in. (160 x 50 cm)
- ☐ 1¾ in. (4.5 cm) battens cut to fit board
- ☐ Synthetic decorator's brush
- ☐ White matte emulsion (latex)
- ☐ Sandpaper and tack rag
- ☐ Acrylic matte varnish
- ☐ Acrylic scumble glaze
- ☐ Watercolor paint set
- ☐ Watercolor paper
- ☐ Universal tint colorants in burnt umber, raw umber, violet, ultramarine, and white
- ☐ Sample pots of matte emulsion or decorative stencil paints in white, pale blue, pale gray, pale lavender, muddy brown
- ☐ Artist's acrylics in raw umber, burnt umber, ultramarine, cobalt, alizarin crimson, and white
- ☐ Artist's sable and fitch brushes
- ☐ Hog hair softener
- ☐ 2 in. (5 cm) and 3 in. (7.5 cm) glider, varnish or similar brushes for applying glazes
- ☐ Methylated spirits and lint-free cloth/kitchen towel

PREPARATION: Prepare the battened board following the instructions on page 9. Base paint with two coats of white matte emulsion and sand after each coat to create a smooth surface. Use a tack rag to remove all traces of dust, and then apply one coat of acrylic matte varnish. Make up some glaze for different washes—mix 6½ fl oz. (200 ml) of water-based glaze (see recipe, page 16), and divide into three containers. Tint the three glazes as follows: one pale gray–blue using cobalt blue, white, and a raw umber tint colorants; one medium blue using cobalt blue, violet, and raw umber tint colorants; and one gray using raw umber, white, and one drop of black tint colorant.

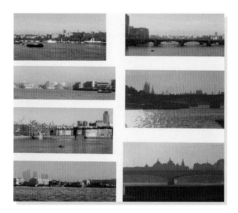

STEP 1
If you are able to, make a trip to the river in your nearest city and spend time taking photographs, sketching, or painting small studies. This is an excellent way to immerse yourself in the atmosphere of a city river. Take or collect a selection of photos of the city skyline as viewed from the banks of the river. Alternatively, look through books and magazines for pictures of different city rivers.

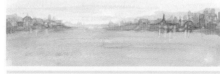 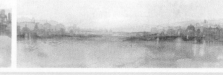

STEP 2
Make some loosely worked watercolor sketches on a wide horizontal format from your city river photographs.

STEP 3
Use the white, pale blue, pale gray, and pale lavender matte emulsion to paint the first block-fill layer. First apply the white to the upper half of the board and brush over some pale blue, blending it with the white. Then brush on some pale gray to the lower half of the board, blending in the pale lavender and patches of pale blue into the gray.

STEP 4

After referring to your photographs and watercolor studies, use the pale gray and muddy brown matte emulsions with a fitch brush to paint in the silhouette of the horizon on the right and left side of the board along the line where the pale sky and darker water color meet. The silhouettes should taper off to leave a space in the center of the board.

STEP 6

Use the three glazes to mute the picture. Wash the pale gray–blue over most of the sky, but leave the skyline at the center of the picture as it is. Apply the gray glaze over the buildings. Also use this glaze to paint in some simple shapes as a differentiation between buildings. Then apply the medium blue glaze over the water, also blending a little of the gray glaze to this as well. Add more glaze as necessary to start to create an atmosphere of dusk.

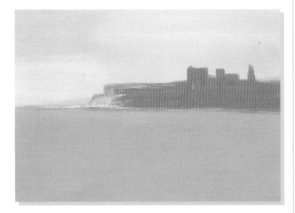

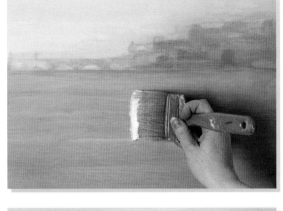

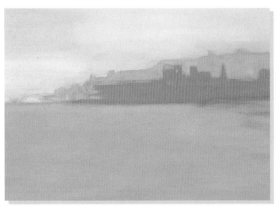

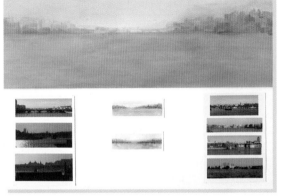

STEP 5

Mix some white into the pale gray to make a lighter gray, and then add some paler silhouettes behind the blocks to the left and right of the picture. Lightly use the same color to paint a faint bridge shape in the center of the picture, creating the effect of a distant silhouette.

STEP 7

Mix a watery muddy gray by adding some raw umber and ultramarine artist's acrylic to the gray glaze. Mix a pale blue–gray glaze by adding white to the medium blue glaze. Use these two colors to paint in different elements and angles of the buildings across the middle of the picture. Refer to your photographs and sketches for different building shapes, and transfer these to the painting.

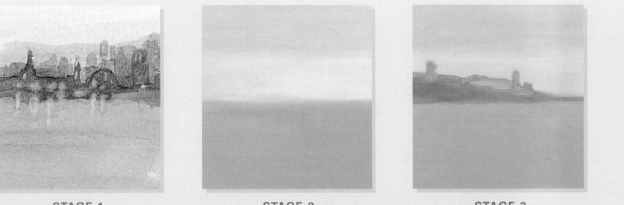

STAGE 1 **STAGE 2** **STAGE 3**

Add a little more white to the pale blue-gray glaze. Use this and the muddy gray to pick out details on the buildings, including architectural features and some areas of light and dark as well as a few pale window shapes. These markings should be fairly indistinct and not overly finished.

Mix a watery off-white, and use a sable brush to pick out the lights in the buildings. Alter the intensity of different lights, varying the size and position of the lights across the skyline. Add some corresponding reflections of light in the river water. Use white, off-white, and pale yellow, varying the intensity of pigment to create the effect of the lights twinkling, but keep this effect subtle.

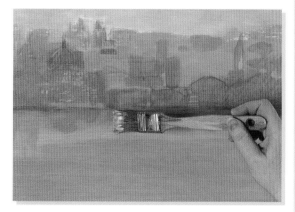

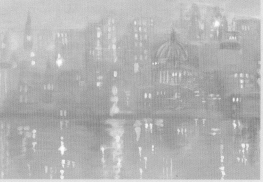

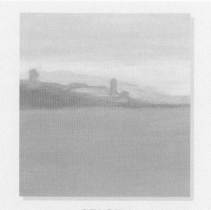

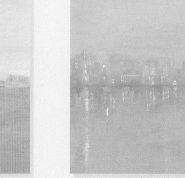

STEP 9
Use the muddy gray wash to paint in some loose reflections on the waterline where the buildings meet the river. Use the softening brush to blend these reflections and make their outlines less distinct. Then apply further washes of the medium blue and gray glazes over the water to blend in and build up the appearance of shadows and darker areas within the water.

STEP 11
Finally, add further pale washes to the sky and water to add to the atmosphere of dusk and blend or knock back any aspects of the painting that stand out too much—the whole painting should have a unified feel.

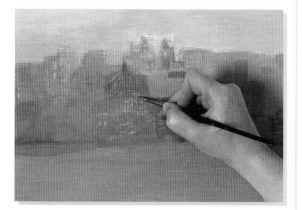

STAGE 4 **STAGE 5** **STAGE 6**

STEP 3

Referring to a Japanese or Chinese blossom print, lightly draw out a branch of blossom using the terra-cotta pastel or Conté crayon. Position the blossom branch between the upper mountain picture and ceramic bowl foreground—this will act as a middle focal point for the picture. If you are not confident about freehand drawing, enlarge your blossom print and use the transfer method to copy it to the board (see page 13).

STEP 5

Use the burnt umber, leaf green, and soft red watercolors mixed to a watery consistency to lightly over-paint the drawing lines of the blossoms, leaves, and wood of the blossom branch. Then apply a light wash to the central shapes of these motifs, keeping the effect toned down and subtle (mix a little burnt umber into the green and red if they are too bright in tone).

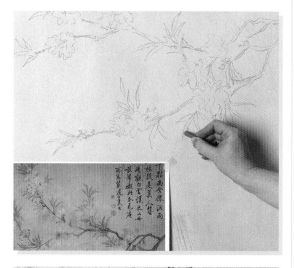

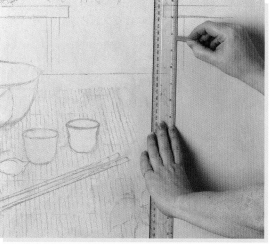

STEP 4

Use a ruler and the Conté crayon to draw in the outline of a simple fence or railing under the blossom. This gives a visual reference and placement to the objects at the front of the picture plane, so they are no longer floating in space.

STEP 6

Use the dusky pink/soft red pastel to draw in the petal details of the blossom flowers—you can draw this quite loosely over the red wash below. Use the white pastel to add some highlights to the ceramic bowls.

STAGE 1

STAGE 2

STEP 7

Gather your calligraphy motifs, either scripts taken from Japanese and Chinese books and prints or the motifs from the Template section. Enlarge a selection on a photocopier so that you have a choice of large bold and smaller detailed motifs, along with some of the red patterned stamp and seal motifs. Arrange these on the decorated board or wall space with transfer paper fixed behind each sheet.

STEP 8

Trace over each motif using a hard pencil, then use a fine sable brush and the black Chinese ink to paint the outlines of the motifs. Use a medium sable brush to fill the shape; apply a second coat as necessary. Lay the board flat while painting to prevent the ink or paint from running. Alternatively, if you are working on a wall, work with black gouache mixed to a thicker consistency, use a drier brush, and apply successive layers to build up opacity as desired.

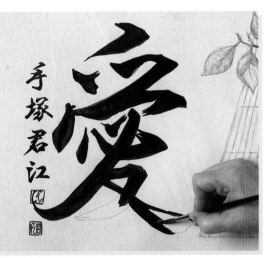

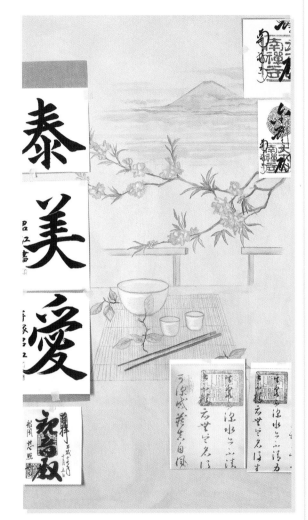

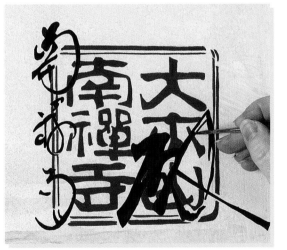

STEP 9

For motifs with red seals behind, fill the red in first in the same way as Step 8, using the vermilion red gouache paint mixed to the consistency of cream. Once the red paint has dried, fill in the black calligraphy shapes in the same way. Once the black ink and red paint are completely dry, use a plastic eraser to remove any visible transfer marks.

STAGE 3

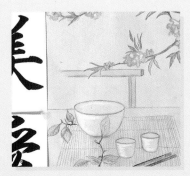

STAGE 4

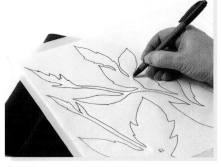

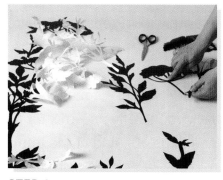

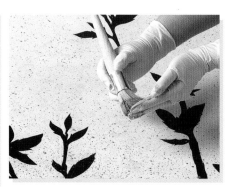

STEP 4

Unroll the sticky-backed craft paper, smoothing out any creases. Lay some wax-free transfer paper face down on top, and position the enlarged template drawings over this. Work one at a time, and position the templates as economically as possible across the sticky-backed paper, interlocking leaves and shapes as necessary. Use a pen to trace over the outlines of the template drawings to transfer the image onto the sticky-backed paper. Repeat this process for each template.

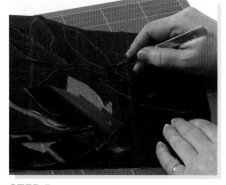

STEP 5

Place the sticky-backed paper onto a cutting mat, and use a scalpel or craft knife to cut through the craft paper and cut out each shape. Cut away the area around the flowers and stalk, leaving the silhouette intact as one continuous piece. Cut out any gaps between leaves, stalks, or flowers that may be joined together. Continue cutting until you have the whole set of silhouettes—lay them out flat on a piece of paper so they are ready to use.

STEP 6

Lay the glazed board onto a large table to work on flat. Place the giant hogweed stencil in position on the board, and then position the cow parsley silhouettes on top to gauge the position of the silhouettes in relation to the stencil. Carefully slide the stencil out from underneath the silhouettes. Stick the silhouettes to the board one at a time. Peel away the backing paper a little at a time, sticking down as you go to prevent wrinkles from forming. For any shapes that will not lie flat, cut the stalk and stick down separately. Smooth out any wrinkles to prevent the spattered glazes from bleeding underneath the silhouette shapes.

STEP 7

Place newspaper underneath and around the board to protect the surrounding area during the spattering process and ensure the board stays flat until the spatter has dried to prevent any paint from dribbling down the board. Now extend the three original glazes for spattering—you need enough glaze to dip the spattering brushes into. The glaze should have the consistency of just between light cream and milk. To do this, add a little extra acrylic matte varnish and water as well as a few extra drops of tint colorant to each glaze.

STEP 8

First spatter with the darker green glaze over the bottom half of the board using a large stencil brush. To spatter, dip the brush into the glaze and then push your free hand through the bristles of the brush while aiming the brush at the board. Repeat this process through different positions on the board to produce a finely speckled effect. Continue until the bottom of the board has a veil of color over it with a little spatter toward the top.

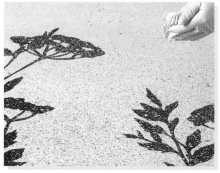

STEP 9

Use a larger brush, such as a stiff bristled washing-up brush, to spatter the paler green glaze over the whole board but more densely toward the bottom of the board. The stiffer and larger brush will produce larger spatters and cover the area faster. Repeat the spattering process at the top of the board with the pale blue glaze and larger brush.

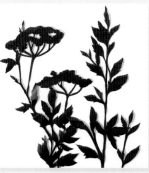

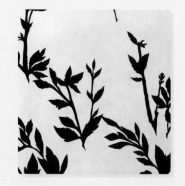

STAGE 1 **STAGE 2** **STAGE 3** **STAGE 4**

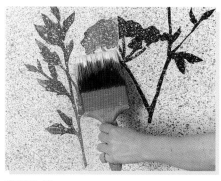

STEP 10

Leave the spattered glazes to dry completely. Then make a tinted pale gray varnish using acrylic matte varnish with 4 drops white, 2 drops raw umber, and 1 drop black tint colorant. If you prefer, you can now work on the board in an upright position. Apply the tinted varnish in long, smooth stokes over the whole of the spattered board. The varnish seals the spattering and blends the different colors together, creating a unified effect. It will also give the silhouettes crisp edges.

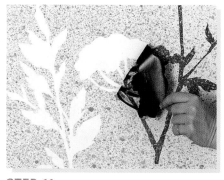

STEP 11

As the varnish is drying, carefully peel away the silhouette cut-outs to reveal the pale green silhouettes. Leave to dry completely.

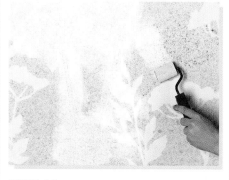

STEP 12

Apply repositionable spray adhesive to the back of the different stencil sections and position the upper stencil over the silhouettes at the top of the board. Press the stencil down fully, ensuring all cut-out shapes and bridges are fully secured to the board. Pour some white and ivory stencil paint onto a plate. Dip the stencil roller into the ivory paint, and roller over the spare portion of the plate to spread the paint over the roller head. Now roller over the stencil, covering all the cut-out parts.

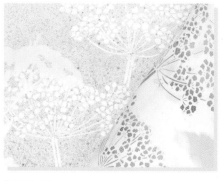

STEP 13

Allow to dry (or use a hair dryer to speed up drying), and then re-roller over the stencil again, adding a little white stencil paint to the roller. Repeat until the stenciled areas are fully opaque and covering the underlying spatter work. You can peel away the top section of the stencil to check for opaqueness before removing the whole stencil.

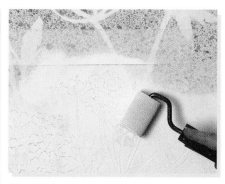

STEP 14

Stick the lower part of the stencil to the bottom of the board and repeat the stenciling process, checking that the stenciled areas are fully opaque before removing the stencil.

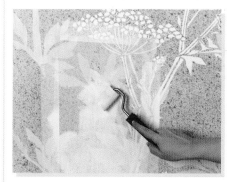

STEP 15

Use the third leaf and stem section of the stencil to add extra stenciled foliage shapes to the bottom of the board, stenciling in white in the same way and masking off the edges of the stencil to prevent paint from smudging over the edge of the stencil.

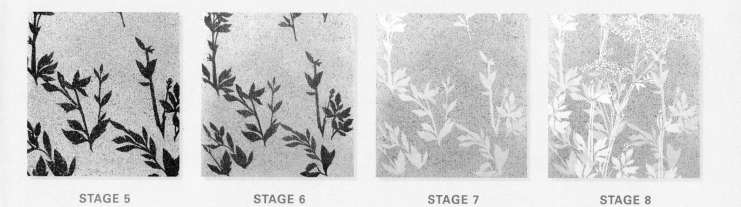

STAGE 5 **STAGE 6** **STAGE 7** **STAGE 8**

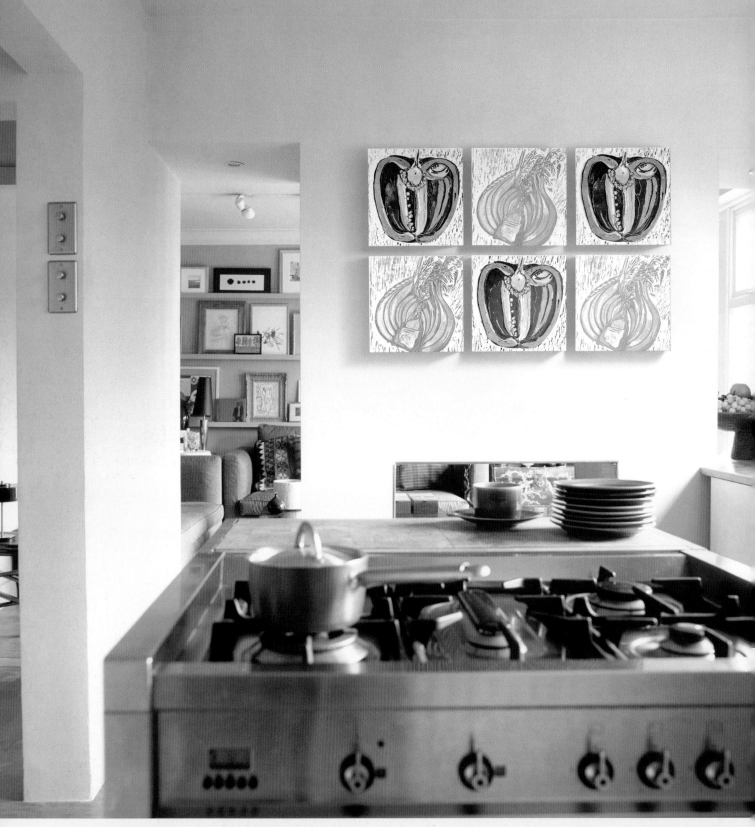

FOOD ART

Create these fun and funky vegetable prints for a real splash of color—ideal for kitchens and open-plan spaces. This project utilizes the enjoyable technique of color-reduction lino block printing to create a series of modern prints, mounted in a checkerboard block of six for a lively injection of style.

COLOR-REDUCTION LINO PRINTING

Linoleum (lino) is made of pressed cork and linseed and is a firm but pliable surface, perfect for carving. This printing method works on the principle of cutting successive layers/sections of lino away and printing each color over the last. The first areas to be cut away are those that are to be left white (or the color of the printing paper). This is followed by the next lightest color and so on through successive layers, with each color becoming more intense. The result is an original color print with a unique textural charm.

Lino printing is a negative printing process—this means that only the section that is left intact (i.e., not cut away) is printed. It is also a reverse process; a printed image comes out as a reverse of the original drawing.

LINO CUTTING TECHNIQUES

Most lino cutting kits contain 10 blades. Try each blade on some spare lino to see the different marks each one makes. The blades used here are number 7—the wide flat-bottomed U-shaped blade for removing large areas, and number 9—the narrow V-shaped blade for cutting fine lines and outlines.

To cut, hold the handle of the lino tool cupped in the palm of your hand with your forefinger on the top of the handle. Place the lino on a bench hook and push the tool into the lino, holding it parallel to the surface and guiding it carefully. The harder and deeper you press, the wider and deeper the line, whereas lighter pressure will create finer lines.

Use a wax crayon to make a rubbing of the block to see how your cutting is progressing.

Lino cutting blades, numbers 1 to 10 (top to bottom).

PREPARATION: To make up the six battened boards for mounting your prints, follow the instructions on page 9. Base paint the made-up boards with two coats of white matte emulsion, sanding between coats. To make up a bench hook for cutting the lino on safely, follow the instructions on page 19.

This project comprises two designs of vegetables or fruit, so the first job is to choose your subject. The best subjects are those that have a simple form with strong structural, textural, or pattern elements. A pepper and fennel have been chosen here for their contrasting qualities.

PROJECT MATERIALS

SAFETY TIPS

☐ Make a bench hook to cut on (see page 19).

☐ Always cut toward the battened edge of the bench hook and away from yourself.

☐ Turn the lino block around so you always cut away from yourself. Every time a line changes angle, turn the block around to face the top of the bench hook.

☐ Never put your hand in front of the lino-cutting tool to steady the block. Always push the block firmly up against the battened edge of the bench hook to steady the lino and keep your free hand behind the tool.

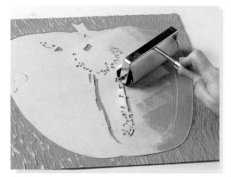

STEP 11

Use the white lino printing ink tinted with a little vermilion ink to make up enough pale apricot ink to print six prints. Spoon some ink onto the inking up palette and then dip the lino roller into the ink. Roll it over the palette until it becomes slightly tacky and the roller surface is covered evenly. Roll the ink onto the lino block, covering the block with a film of slightly tacky lino printing ink.

STEP 13

Smooth your hand over the block to ensure the ink has made contact with the paper. Then slide one hand underneath the paper, and with the other hand holding the block steady, turn the block and paper over together. Rub your hand firmly over the entire print, and then burnish with a dessert spoon in a circular motion with a firm pressure. Peel the print away from the block and lay it out to dry. Make six prints. Number each print and wash the block carefully (see tips, opposite).

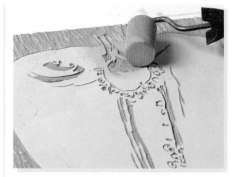

STEP 15

Use the white oil crayon to mark up the areas to be cut away. Use the V-shaped tool to cut away outlines and the U-shaped tool to cut away the pithy area, seeds, and lighter shaded areas of the outer skin and stalk. Also cut away more of the background area so that the textured, printed background will have a variation in colors. Mix a pale yellow–orange color using the white, vermilion, and yellow inks, and ink up the lino block. Also mix a little light green to ink up the stalk area with the small sponge roller.

STEP 12

To make the first print of the first cut, lay a piece of cartridge paper onto a flat, clean surface and lay the inked-up block face down onto the center of the paper. Draw some pencil guides around the four corners of the block to act as registration guides for the following prints.

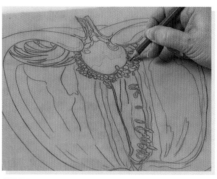

STEP 14

The next stage of the cutting process is to cut away all of the areas of the block that are to remain pale apricot. If the white traced outlines have been washed off the block, lay the original tracing over the block and retrace the main outlines of the drawing back onto the block, particularly those areas that relate to this color.

STEP 16

Once the block has been inked up, lay the first print down on the working surface. Line up the top two corners of the back of the block with the registration marks on the print. Carefully place the block down on the print. Turn the print and block over, and burnish before carefully peeling it away. Continue printing each numbered print in order and lay out to dry. Wash the block carefully as before.

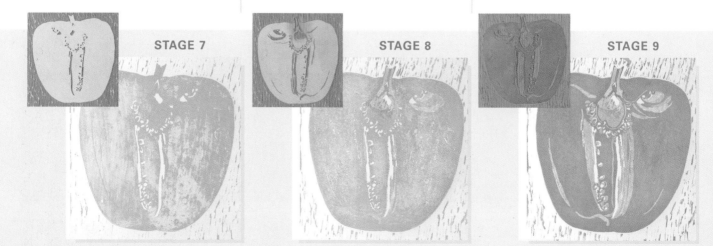

STAGE 7 STAGE 8 STAGE 9

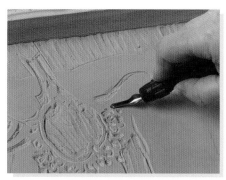

STEP 17

Now cut away all of the areas of the block that are to remain the pale yellow–orange color of the pepper. Retrace outlines as necessary from the original tracing. Refer to the original watercolor or photo for your color reference and mark the block up with the white oil crayon. Cut away the rest of the vertical pithy strips, the core, and most of the seeds, and also cut away a little more of the background area. Mix up a natural orange color using the vermilion, yellow, and a tiny drop of green. Ink up and print as before, and then clean the block.

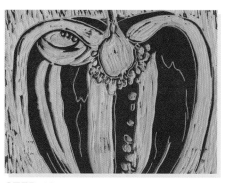

STEP 18

Cut away the areas that are to remain orange in the pepper including the cross section of the skin all around the pepper, except the very outer edge, and more areas of the inside flesh. Use the bright vermilion red ink to print the six prints as before. Clean the block.

STEP 19

Cut away the areas that are to remain vermilion, which include all of the rest of the block except the darkest inner shadows and darker colors of the skin, which will be printed with a darker magenta crimson. Cut more detail into the stalk, and cut away more of the background area. Mix a magenta crimson with the crimson ink and a little ultramarine artist's acrylic and print the pepper. Add a little green to the stalk to all six prints.

STEP 20

Repeat this whole process for the second lino design such as the fennel used here or another vegetable.

STEP 21

Leave the finished prints until completely dry to touch. Then use a sharp scalpel or craft knife to trim the three best pepper prints and the three best fennel (or other) prints to 12 in. (30.5 cm) square to fit exactly onto the battened prepared boards.

STEP 22

Spray permanent spray adhesive liberally onto the reverse side of the print, and run a glue stick around the edges of the print. Line the print up with the block. Push the print down from top to bottom, pressing and smoothing it firmly until it lies flat and any wrinkles in the paper have been eased out. Repeat for each of the prints.

STEP 23

Hang the six mounted prints in a block of two by three, alternating the two different vegetable designs to create a checkerboard effect. Leave a distance of approximately 1 in. (2.5 cm) between each mounted print.

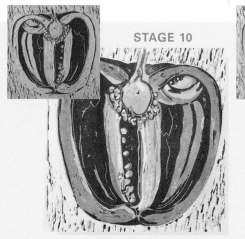

STAGE 10

STAGE 11

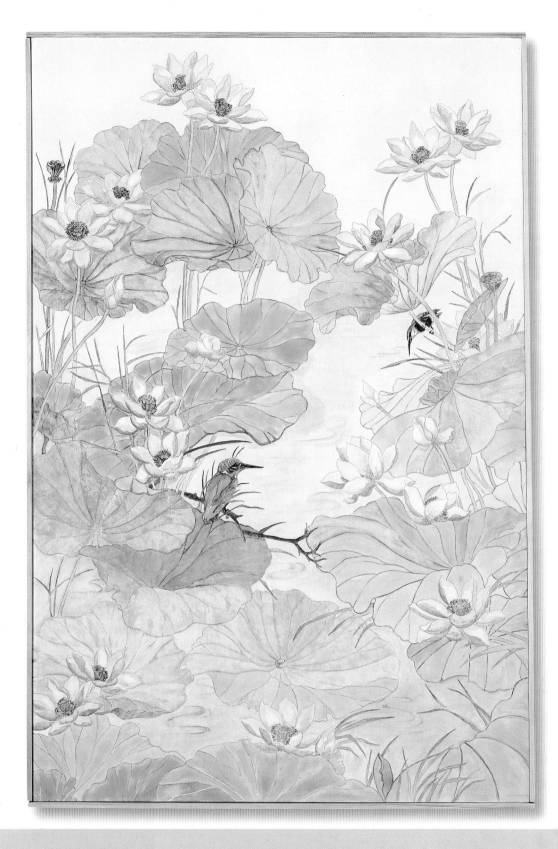

WATERSIDE MURAL

This delicate watercolor mural on a gesso ground has a beautiful illustrative and imaginative quality—a perfect decorative feature for watery rooms! Delicate and modern, graceful and bold, this beautiful mural board sets a contemporary tone for creating a sense of calm in bathroom spaces.

PREPARATION: Make up the battened board following the instructions on page 9. Paint with two coats of acrylic gesso primer. After the first coat has dried completely, use fine sandpaper to sand the surface thoroughly. Remove the dust, then wipe over the board with a tack rag to remove all traces of dust. Repeat this process with a second coat of gesso primer and then apply one smooth coat of acrylic matte varnish.

TOOLS & EQUIPMENT

47 x 31½ in. (120 x 80 cm)

- ❑ ¼ in. (6 mm) MDF board 47 x 31½ in. (120 x 80 cm)
- ❑ 4 x 1½ in. (4 cm) battens cut to fit board
- ❑ Acrylic matte varnish
- ❑ Synthetic decorator's brush
- ❑ Acrylic gesso primer
- ❑ Fine sandpaper
- ❑ Tack rag
- ❑ Blue wax-free transfer paper
- ❑ Fine, medium, and large artist's sable brushes
- ❑ Artist's watercolor set

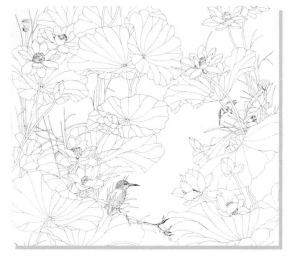

STEP 1
Enlarge the Waterside Mural drawing from the Templates section (see page 121) by 470% to 47 x 31½ in. (120 x 80 cm) to fit the board. Then use blue transfer paper to transfer the drawing onto the board (see page 13 for transfer method).

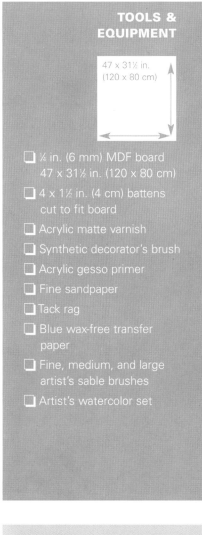

STEP 2
Use the watercolor paints to mix a watery pale green, using brown, yellow ocher, and blue. With a fine sable brush, paint over the blue outlines of all the large lily leaves, filling in the stems and grasses as you go.

PROJECT MATERIALS

SEE ALSO:
FINISHING, PAGES 24–25
BAMBOO & MOON, APPLYING WHITE POLISH SHELLAC, PAGES 30–33
FRAMING BATTENED BOARDS, PAGE 25

STEP 3

Mix white into the remainder of the green wash and over-paint the flower outlines in very pale green. Then use a combination of pale green, raw sienna, and terra-cotta shades to paint the flower centers and stamens.

STEP 5

Add textural quality to some of the leaves by dabbing lightly with a clean paper towel.
To paint the lily flowers use a combination of white, pale green, and light sage green. Paint the inner petals with pale green and the curling outer petals with light sage green.

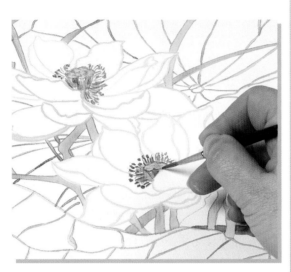

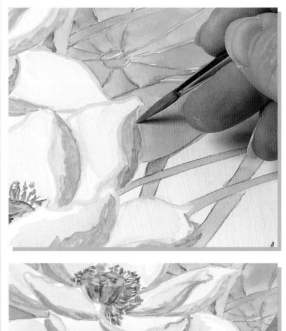

STEP 4

Use a large sable brush to paint the large lily pads in varying tones of soft green mixed with browns, ochers, and blues. For each leaf, mix enough watery paint to paint the whole leaf with the same tone. Vary the tones from leaf to leaf, making some bluer and some greener.

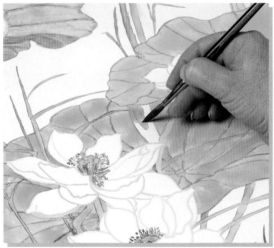

STEP 6

Add white highlights to parts of the inner petals, and then add extra definition to the flower centers and stamens with orange, vermilion, and burnt sienna shades using a fine-tipped sable brush.

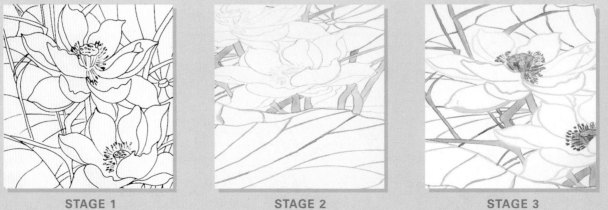

STAGE 1 STAGE 2 STAGE 3

STEP 7

Paint the water areas of the pond with a very watery pale blue mix, using a large sable brush to apply the wash. Add texture by dabbing with some clean paper towel as desired. Use the same paint mix and same large brush to add some light water swirls.

STEP 9

Use red and orange for the feet, feathers around the eyes, and lower beak, and use dark brown and black for the eye. Use a clean wet brush to lift some of the paint from the wings, tail, and head. This softens the colors and brings the kingfisher into harmony with the rest of the picture.

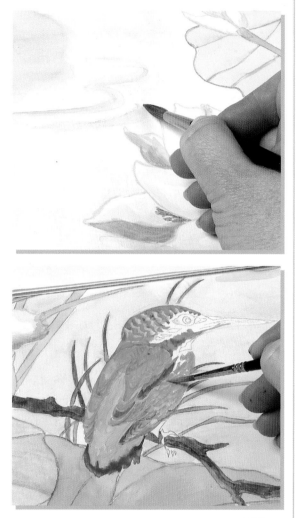

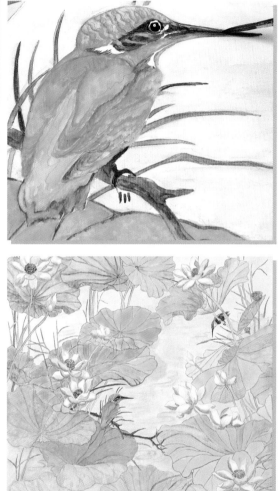

STEP 8

To paint the kingfisher birds, first paint the grasses and twigs around them in greens and browns, and then mix some bright turquoise, sea green, and ultramarine, and paint the wings, back, tail, and feathers on the head as illustrated.

STEP 10

Stand back from the picture and look at the color balance. Alter tones and add depth or brightness as needed. To seal and protect the watercolor paint, apply a coat of white polish shellac. Let dry, then apply one coat of acrylic matte varnish.

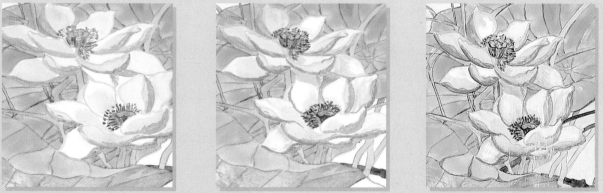

STAGE 4 STAGE 5 STAGE 6

ABSTRACT SHELL DETAIL

This striking and stylish painting is a close-up of one of nature's beauties—a cowrie shell—created by using a small viewfinder to select a tiny portion of the shell and magnifying it to oversize dimensions to produce this interesting and mood-setting abstract. This approach can be adapted for other found objects. Collect different seashells, coral, driftwood, or pebbles as inspirations for your painting, and study the surface textures and patterns of each object to select one as your main subject.

TOOLS & EQUIPMENT

15 x 15 in.
(38 x 38 cm)

- ☐ ¼ in. (6 mm) MDF board 25½ x 25½ in. (65 x 65 cm)
- ☐ 1½ in. (4 cm) battens cut to fit board
- ☐ Synthetic decorator's brush
- ☐ Acrylic gesso primer
- ☐ Sandpaper and tack rag
- ☐ Acrylic matte varnish
- ☐ Acrylic scumble glaze
- ☐ Watercolor set
- ☐ Watercolor paper
- ☐ Set of colored soft pastels
- ☐ Card, ruler, pencil, and sharp knife for making viewfinder
- ☐ Universal tint colorants in burnt umber, burnt sienna, raw umber, yellow ocher, and white
- ☐ Artist's acrylics in vermilion, alizarin crimson, ultramarine blue, burnt sienna, burnt umber, raw umber parchment, white, lemon yellow, cadmium yellow
- ☐ Oil crayon in terra-cotta
- ☐ Artist's sable and fitch brushes
- ☐ Hog hair softener
- ☐ 2 in. (5 cm) and 3 in. (7.5 cm) glider varnish brushes or similar for applying glazes
- ☐ Methylated spirits and lint-free cloth/kitchen towel
- ☐ White polish shellac and acrylic eggshell or gloss varnish (optional)

PREPARATION: Prepare the battened board (see page 9). Apply one coat of acrylic matte varnish to seal it. Then apply the first coat of gesso (watered down with one-third water) brushed on smoothly with a wide synthetic brush. Once dry, sand smooth, and remove dust with a tack rag before applying a second coat. When dry, seal with another coat of varnish. Mix 6½ fl oz. (200 ml) of water-based glaze (see page 16) for the shell washes. Divide into three containers and tint each as follows: dark brown using burnt umber, raw umber, and burnt sienna tint colorants; terra-cotta using burnt sienna, yellow ocher, and one drop of white; and pale ocher using yellow ocher, white, and one drop each of burnt sienna and raw umber tint colorants.

STEP 1
Use the card to make a small square viewfinder—its dimensions will depend on the size of your shell and the amount of pattern you want to include in the painting. The shell pattern should fill the whole of the viewfinder when it is placed directly over the shell. Draw a guide mark at the center of each edge of the viewfinder to help you view the square section in four quarters.

STEP 2
Draw a 6 in. (15 cm) square onto watercolor paper with guide marks at the center of each edge to correspond with the marks on the viewfinder. Place the viewfinder directly over the shell, and then make a watercolor study of the shell using a restricted palette (see page 14). Lightly plot in the small circles of the cowrie shell. Then add several watercolor washes over the whole area and paint the small circles, building up color and intensity.

PROJECT MATERIALS

STAGE 1

STEP 3

Use the terra-cotta oil crayon to plot in the circles of the cowrie shell, enlarged to the scale of the board. Refer to each quarter of the watercolor study and observe the position of the circles in relation to each other within the quarter—you can rub out and correct any mistake as you work. Apply the yellow ocher glaze over the whole board using the 3 in. (7.5 cm) glider and softening brush.

STEP 5

Continue painting the circles using this technique, referring to your original watercolor and using the two tones of brown glaze to build up different intensities and depths between the circles—also partially overpaint some of the circles.

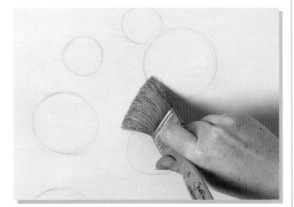

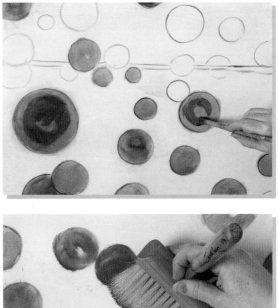

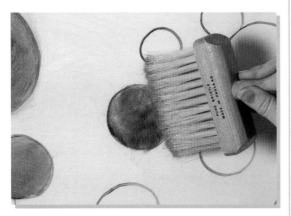

STEP 4

With the sable brush, lightly paint the brown glaze over the outlines of the circles. Use a fitch brush to paint inside the circles loosely with both the terra-cotta brown and dark brown glazes, lightly dusting the softening brush over the painted circle inward and outward to create soft edges.

STEP 6

Now start to work into the area around the circles. Make a pale gray wash by mixing a little ultramarine into the light yellow ocher glaze and loosely brush this around some of the circles, immediately softening the edges of this with the softening brush. Build up the effect with the dark brown glaze with a little water added.

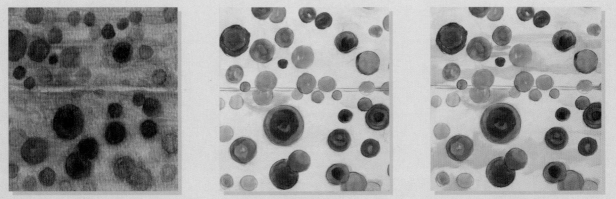

STAGE 2 STAGE 3 STAGE 4

STEP 7

Loosely paint and soften some terra-cotta glaze around a few of the circles. Then use a little white artist's acrylic mixed with the yellow ocher glaze to add a light line horizontally across the center of the picture.

STEP 9

Allow the board to dry completely. Then dip a piece of kitchen towel or lint-free cloth into some methylated spirits and rub back some areas of the board to reveal the base paint beneath—rub away around some of the circles to create some lighter horizontal bands across the board.

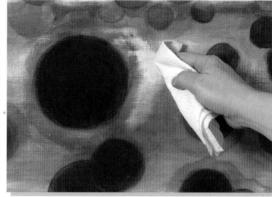

STEP 10

Once the painting is complete, use the 3 in. (7.5 cm) glider to apply a coat of white polish shellac over the whole surface—the shellac should be applied in long, smooth, horizontal strokes across the board. Allow this to dry for an hour, and then apply a final coat of shellac or seal with a coat of acrylic or eggshell varnish depending on the level of sheen desired.

STEP 8

Now loosely brush on the brown glaze with the 3 in. (7.5 cm) glider—spread the glaze lightly over the whole board and then soften with the hog hair softener.

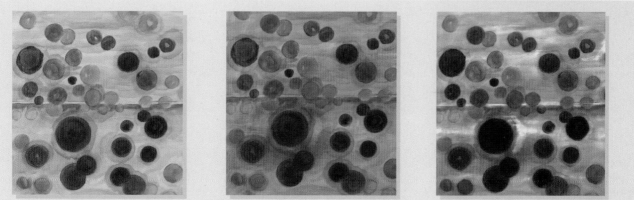

STAGE 5 **STAGE 6** **STAGE 7**

COAST

This calming seascape captures the peace and serenity of northern coastlines—rocky cliff structures that meet the sea in numerous coves and bays with cool open skies and blue-gray, cold waters—ideal for bathrooms and watery spaces. The composition of this painting is of a receding landscape with a strong perspective, enhanced by the painting being applied to a tall, thin board. The atmosphere is created through successive layering of soft washes, with detail added gradually. The use of a restricted color palette lends the painting both uniformity and a sense of harmony. Both of these techniques assist beginners to make an impressive start to landscape painting.

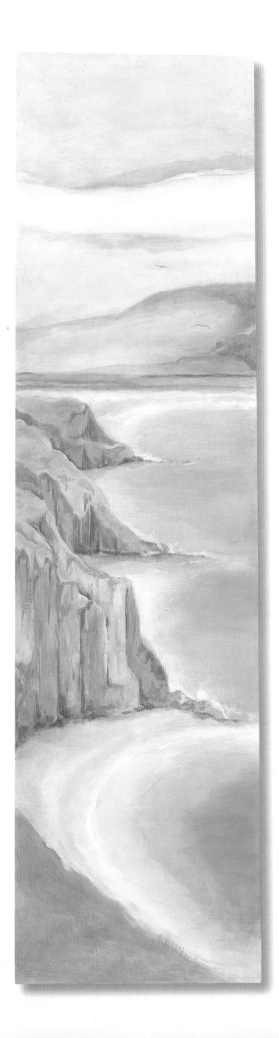

TOOLS & EQUIPMENT

15¾ x 59 in. (40 x 150 cm)

- ❏ ¼ in. (6 mm) MDF board 15¾ x 59 in. (40 x 150 cm)
- ❏ 1¾ in. (4.5 cm) battens cut to fit board
- ❏ Synthetic decorator's brush
- ❏ Acrylic gesso primer
- ❏ Sandpaper and tack rag
- ❏ Acrylic matte varnish
- ❏ Inspirational photographs and source pictures of coastlines
- ❏ Acrylic scumble glaze
- ❏ Universal tint colorants in yellow ocher, yellow, cobalt blue, raw umber, burnt sienna, and white
- ❏ Artist's acrylics in white, cobalt blue, raw umber, yellow ocher, raw sienna, and burnt sienna
- ❏ Artist's sable and fitch brushes
- ❏ Hog hair softener
- ❏ 1 in. (2.5 cm), 2 in. (5 cm), and 3 in. (7.5 cm) glider varnish brushes or similar for applying glazes
- ❏ Watercolor set
- ❏ Charcoal for sketching

PROJECT MATERIALS

PREPARATION: Prepare the battened board (see page 9). Apply a coat of acrylic matte varnish to seal it. Then brush on the first coat of gesso (watered down with one-third water) with a wide synthetic brush. Once dry, sand, remove dust with a tack rag, and apply a second coat of gesso. When dry, apply another coat of varnish. For the seascape washes, mix 6½ fl oz. (200 ml) of water-based glaze (see page 16). Divide into three containers and tint as follows: one pale blue using cobalt blue, white, and a little raw umber tint colorant; one gray using raw umber, white, and a little cobalt blue tint colorant; and one sandy color using raw umber, yellow ocher, white, and a little burnt sienna.

STEP 1
Collect different seascape pictures, and cut tall thin sections through them to make a selection of images that have the same thin dimensions that your large-scale painting will have. Make up some preparatory studies using a palette of pale blue, gray, and sand. Practice building up washy layers.

STEP 2
To start the main painting, use a fine fitch brush and the pale blue glaze to draw in the outlines of the main sections. The painting in this example has three coves, with cliffs in the foreground and mid-ground, and a horizontal break across the top third of the picture as the beach and a low hill stretch across the picture. Start by plotting in the bay in the foreground.

STEP 3
Continue working up the board, plotting in the second and third cove and then the horizontal line of the beach marking the upper third of the painting and the low rising hill above it.

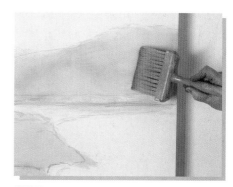

STEP 4
Now build up the wash effect with the three glazes. First apply the gray glaze to the main landmasses and bands across the upper sky. Apply the glaze with a 2 in. (5 cm) glider in loose strokes over each area. Then soften with the hog hair softener, stroking it lightly across the glaze in vertical, horizontal, and crisscross movements. To create more subtle effects, you can also use a cloth to dab off some of the glaze before softening.

70

STEP 5

Apply the sandy-colored glaze using a wide fitch and softener to create soft bands of color across the beach areas and some of the rocky faces of the cliffs. This color can also be applied to the sky and over areas of gray glaze.

STEP 7

The next stage is to build up the glaze layers by adding further washes. Use a 1 in. (2.5 cm) glider and softening brush to add more blue glaze to the cliff and rock structures, the sky, and areas of seawater. Add the gray glaze and a little more sandy glaze to rocks and beach and touches to the sky. Continue to apply the glazes in the same way, gradually building the depth and tone in the seawater, land areas, and as banks of clouds in the sky.

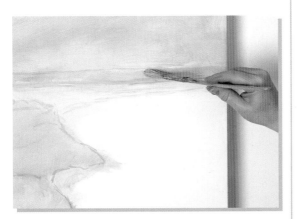

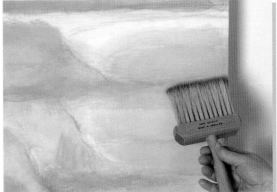

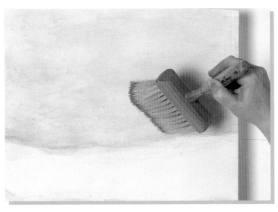

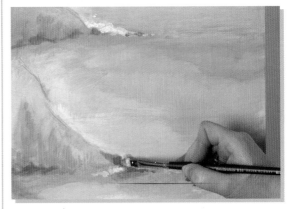

STEP 6

Use the 3 in. (7.5 cm) glider and hog hair softener to create soft washy bands across the sky with the blue glaze and to cover areas of sea and rock.

STEP 8

Use the artist's acrylics to mix a blue (cobalt, raw umber, and white), gray (raw umber, cobalt blue, and a little white), and white ("dirtied" with a little of the gray just mixed). Work with a fitch brush in loose brushstrokes to add a little white to the water where it meets the base of the cliffs, gray to the bases of the cliffs, and blue to areas of the seawater.

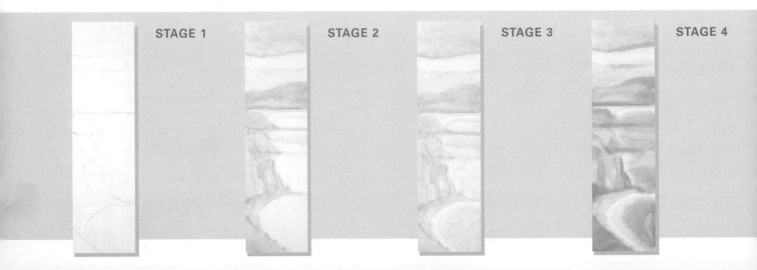

STAGE 1 STAGE 2 STAGE 3 STAGE 4

STEP 9

Add a line of more defined light under the bank of clouds using white (toned down with a little raw umber). Mix white with yellow ocher, raw sienna, and raw umber for a pale, sandy white and use it to paint the headlands and parts of the cliffs. Add more white to the mixture to create a few highlights. Add some of this color to the beaches. Mix two gray tones using white, cobalt blue, and raw umber to add depth and structure to the cliffs and rocks.

STEP 11

Mix a muted medium green using yellow ocher, raw umber, and cobalt blue, and apply a light wash sparingly to the rough ground in the foreground and to "blush" areas of the headlands—keep this effect subtle.

STEP 10

Water the same gray down a little to add further washes to the sea and blend paint strokes on the rocks. Then add some white to this mixture to paint some highlighted brush marks to the rock formations of the cliffs.

STEP 12

To complete the picture add a few subtle final touches, such as some watery highlights in white to the sea—waves lapping on the beach, foam splashing on the rocks—just a few subtle paintbrush strokes will add to this effect. Finally, use a watery mix of white and raw umber to lightly plot in some flying seabirds in the upper third of the picture.

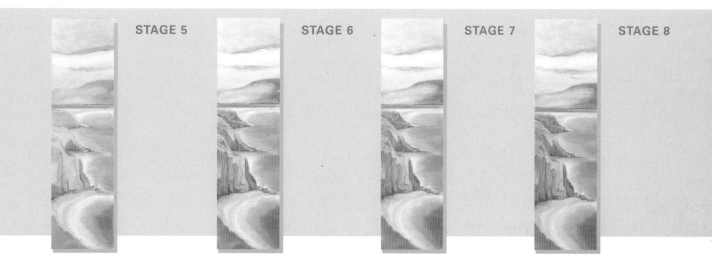

STAGE 5 STAGE 6 STAGE 7 STAGE 8

PHOTOGRAPHIC ART

Simple boards with enlarged photographic images make great wall art for stylish living spaces. These can be blown up as a single, striking poster-sized picture or grouped in twos, threes, or more. Images of fruits, berries, plant skeletons, wild grasses, and sedges make fantastic subjects for photographic art. Here, teasels and Chinese lanterns picked in the autumn season have been photographed against a neutral white backdrop and then blown up and cropped for an impressive effect. The steps of this project lay out how to achieve this photographic finish, but you can alter the dimensions of the photos and the boards to suit your room's proportions.

TOOLS & EQUIPMENT

11¾ x 20½ in.
(30 x 52 cm)
(x2)

- ❏ 2 x ¼ in (6 mm) MDF board 11¾ x 20½ in. (30 x 52 cm)
- ❏ 1¼ in. (3 cm) battens cut to fit board
- ❏ White matte emulsion (latex)
- ❏ 3 in. (7.5 cm) synthetic decorator's brush
- ❏ Sandpaper and tack rag
- ❏ Acrylic matte varnish
- ❏ Digital camera or already-enlarged photocopies/printed photos
- ❏ Access to a computer and Photoshop (or similar photo software package)
- ❏ 2 photographic subjects (such as teasels and Chinese lanterns)
- ❏ Large sheet of white paper or white board
- ❏ CD-ROM
- ❏ Permanent spray adhesive for photos (such as Photomount)
- ❏ Cutting mat, metal ruler, and scalpel or sharp craft knife
- ❏ Newspaper, tissue paper

PROJECT MATERIALS

PREPARATION: Start by collecting subjects to photograph. You will need two different complementing plants to make up a pair. Choose plants that have interesting shapes and features. Be careful of thorns and spikes when picking plants, and pick each specimen with as long a stem as possible. Prepare the battened boards following the instructions on page 9. Base paint with two coats of white matte emulsion, sanding between coats to create a smooth surface. Use a tack rag to remove all traces of dust, and then apply one coat of acrylic matte varnish to each board.

STEP 1
Arrange one or two stems of your chosen plant subjects in two separate tall vases so that the stems and seedpods/heads are standing apart but positioned close together. Then, one at a time, stand each vase in front of a piece of white paper or board. Ensure there is good lighting in the room with no obvious shadows being cast by the plants onto the backing board.

STEP 2
Photograph each plant arrangement, experimenting with different distances and angles. Take the shots reasonably close up so that you can see the plant stem but not the vase it is standing in. A good digital camera will create high-quality photographs when set on Auto, with the camera settings set to Fine, but you can also experiment with the speed and aperture settings of the camera if you choose.

NOTE
Unless the images are perfect, you will need to make alterations to enhance the photographs for enlarging. In this project, the Chinese lantern photograph needed brightening throughout to create a bright white background, whereas the teasel photograph needed general brightening, cleaning up a little, and cropping at the resizing stage to improve the composition of the shot. The steps on the following pages describe how to achieve these alterations in Photoshop

STEP 3

Load the shots onto your computer, and open the JPEG images in Photoshop (or similar software program). Check each photo to select which images to work on. Choose ones that have the best composition and sharpness of image—an enlarged image needs to be sharp and clear either throughout or in one main depth of field. Open on full-screen setting. Press Control + to enlarge the image several times to check it has a good focus and sharp edges. Once you have selected two images—one of each plant arrangement—save them as JPEG files.

STEP 4: CHINESE LANTERN

Open the selected Chinese lantern image.

Go to Image, Adjustment, and click on Auto Color from the scroll-down menu.

Go to Image, Adjustment, and open the Brightness and Contrast window from the scroll-down menu—alter the Brightness by +60 and Contrast by +12 both to lighten and bring out the depth of the image.

To brighten the background to white without bleaching out the orange of the Chinese lanterns, select the Magic Wand tool from the Toolbox menu. Then click on the darker area of the background—the Magic Wand tool will select a portion of the background—use the Brightness and Contrast window to alter the Brightness by +20. Continue using the Magic Wand tool to select all areas of the background, including the small areas between twigs and stems. Lighten all background areas by the same amount or to the same visual degree. Save the image.

STEP 5: TEASEL

Open the selected teasel image.

Go to Image, Adjustment, and open the Brightness and Contrast window—alter the Brightness by +37 and Contrast by −10 to both lighten and soften the image.

Go to Image, Adjustment, and open the Color Balance window. Move the level on the yellow-blue bar toward yellow and set at −12. Move the level on the red-cyan bar toward red and set at +8.

To clean up some of the stray seeds and fluff on the teasel heads, enlarge the image by clicking on Control +. Then go to the Toolbox menu and select the Lasso tool. Carefully draw around the area to be cleaned. Then click on the Pipette tool, position it over the background next to the areas being removed, and click. Then click on the Paint Bucket tool and click on the selected area over the fluff to be removed—repeat clicks until the item has been removed (this creates a softer edit than just deleting the item). Save the image.

STEP 6

To increase the resolution of the images and to resize them to the large format, first create a new file: Go to File and click on New. Set the file parameters as follows: Width 11¾ in. (30 cm); Height 20½ in. (52 cm); Resolution—300 pixels/inch; Mode—RGB. Name the new empty file.

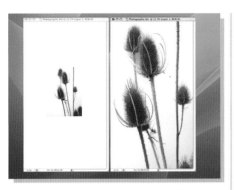

STEP 7

Open both of the final JPEG images. Drag the first image into the new file. To resize the image, press Control T, then hold down the shift key, place the cursor over one of the arrows in the four corners, and enlarge the image so that it fills the window or larger if you are cropping the image. (Note: Always hold down Shift when resizing to prevent the image from elongating or shortening.) Open the Layers dialogue box (go to Windows at the top of the screen and select from the scroll-down menu). You will see your image on the left of this window with an eye symbol next to it—name the image where it says layer 1.

STEP 8

Click on the eye to take the layer you have just created out of view and then repeat the process, dragging the second image into the new high-resolution file. Save the file as a PSD file. Save each image as a JPEG file by clicking on the eye icon in the layers palette and then clicking on Save As from the File menu. Name the image, and change the Format preferences to JPEG. You now have your final images for enlargement. Burn the final images onto a DVD or CD ROM, and take them to a film-processing company for production. Ask for the images to be printed on good-quality paper—this will give the most faithful reproduction.

STEP 9

To mount the enlarged finished photographs, first trim the image to the exact size to fit the board using a metal ruler and sharp craft knife on a cutting mat to cut off the white borders on the enlarged photographs. Check that the images fit the boards.

STEP 10

Lay the first enlarged photo face down on several sheets of newspaper or tissue. Spray a permanent photo adhesive, first from left to right and then up and down, across the back of the photo, holding the spray nozzle at a distance of 8 in. (20 cm). Position the photo carefully so that the top of the photo lines up flush with the top of the board.

STEP 11

Once positioned correctly, lay the photo down onto the board from top to bottom. Then lay a sheet of tissue paper over the image, and press and smooth the photo down with a cloth through the tissue to ensure it is fully stuck down. Repeat for the second photograph.

STEP 12

Wall mount the two photographic boards with a gap of ½ in. (1.5 cm) between them.

COMPUTER-FREE METHOD

This project is aimed at those wanting to develop their photographic and computer skills. You can easily recreate a similar effect by selecting favorite photographs from books or magazines, enlarging them on a color photocopier and mounting them on boards following the mounting instructions above.

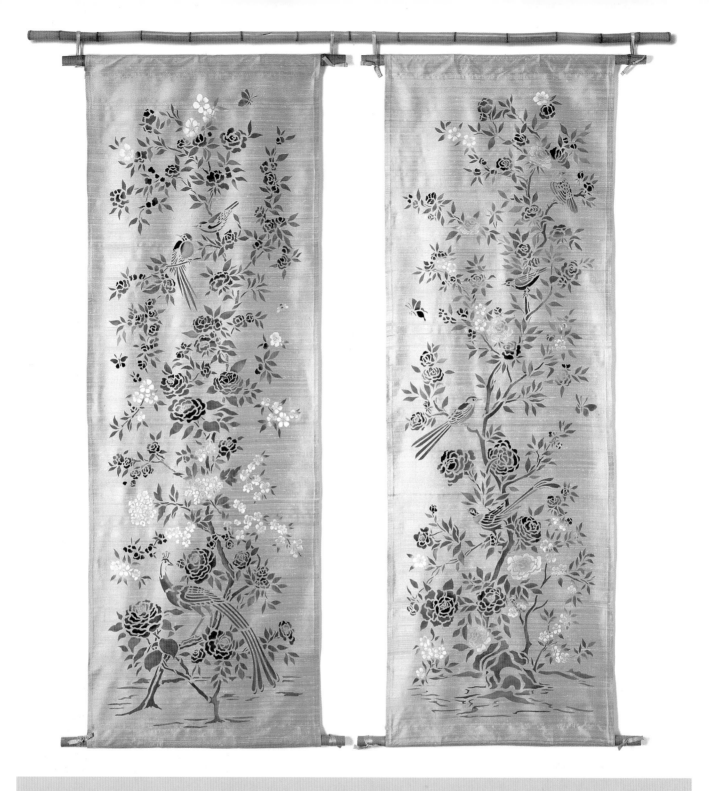

CHINOISERIE PANELS

Make these two exquisite panels using stencils based on original 18th-century exotic chinoiserie designs of trees, birds, and flowers. The traditional colors of a duck egg turquoise silk background decorated with colorful pinks, yellows, blues, and pastel tones have been used here to create a modern version of a timeless classic. The sewing is minimal and best done on a sewing machine. For the sewing phobic, you can also use iron-on adhesive sewing tape to make up the silk panels.

TOOLS & EQUIPMENT

78¾ x 27 in.
(200 x 68.5 cm)
(x2)

For making the silk panels

☐ 87 x 54 in. (220 x 137 cm) turquoise 100 percent silk fabric (can be textured, raw, or smooth upholstery silk)

☐ Sharp material scissors

☐ Tape measure, ruler, set square

☐ Pins and needles

☐ Steam iron

☐ Iron-on adhesive sewing tape or sewing machine

☐ Turquoise sewing cotton to match fabric

☐ 4 x 30 in. (77 cm) length, 1 in. (2.5 cm) diameter bamboo poles or plain dowel poles

For stenciling

☐ Two Large Chinoiserie stencils (see Resource Directory) or similar stencil design

☐ Repositionable spray adhesive

☐ Set square

☐ Wide masking tape and pencil

☐ Stencil sponges or stencil rollers

☐ Divided palette or plate

☐ Fabric paints in medium brown, light brown, light green, blue–green, lilac–pink, pale pink, cerise–crimson, white, yellow, deep turquoise, purple, gold

☐ Lining wallpaper

MAKING UP SILK PANELS

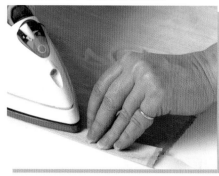

STEP 1

To make up the silk panels, lay the whole of the fabric piece flat and cut off 8 in. (20 cm) across the bottom width of the fabric. Cut down the middle of the length of the fabric to create two long pieces that measure 27 in. (68.5 cm) wide by 78¾ in. (2 m) long. Turn each side edge over by ½ in. (1.5 cm) and press. Turn again by ½ in. (1.5 cm) and press. Insert iron-on adhesive tape into the fold and press with a hot iron or machine sew the side seams using turquoise thread.

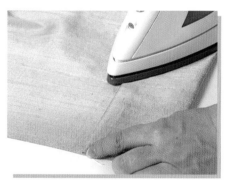

STEP 2

To create the top and bottom hem pockets for the poles, fold the top edge over by ½ in. (1.5 cm) and press. Then fold the fabric over again creating a fold of 2¾ in. (7 cm). Use the iron-on adhesive strip to secure, or, for a stronger hem, use a sewing machine. Repeat this for the bottom edge and for the top and bottom edges of the second panel.

STEP 3

Use the spare 8 in. (20 cm) strip to make up some silk ties for hanging the panels on the poles. Cut eight strips 2 x 9 in. (5 x 23 cm). Fold over the two ends of each strip and then fold along the sides of the strips twice. Either use iron-on adhesive tape or sew.

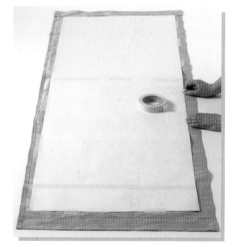

STEP 4

Iron both panels to remove any creases in the fabric and to press the hems. Then attach a large sheet of lining wallpaper to fit the back of the first panel using low-tack masking tape—this makes the fabric firmer while stenciling and protects your work surface. Turn the fabric over and lay it out flat on a large tabletop or other suitable surface.

SEWING MATERIALS **STENCILING MATERIALS**

STENCILING THE CHINOISERIE PANELS
STEP 1

Apply repositionable spray adhesive to the reverse side of the top section of the first chinoiserie stencil (or similar design). Stick the stencil to the top of the silk panel using a set square to ensure the stencil is lying square on the fabric. Smooth over the whole stencil, ensuring all cut shapes and bridges are fully stuck down to the fabric to prevent any seepage during stenciling.

STEP 3

Pour some medium brown, light brown, light green, blue–green, lilac–pink, pale pink, cerise–crimson, white, and yellow fabric paint into a divided palette. First, stencil the tree trunks and flower stalks in the two browns. Use the stencil sponge, dipping it into the paint and dabbing off the excess on a paper towel before applying to the silk. Use the two greens to stencil the leaves and flower stems.

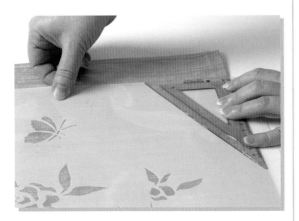 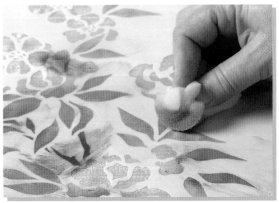

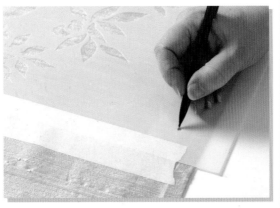 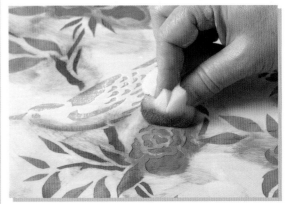

STEP 2

Use wide low-tack masking tape to mask off the edges of the stencil to prevent any paint from smudging over the edge. Use a pencil to mark through the two registration dots lightly at the bottom of this stencil section—this will help you align the second part of the stencil later.

STEP 4

Stencil in light sweeping movements, varying the intensity of the color throughout to create variation and depth. Use the lilac pink to stencil the lower petals of the rose flowers and buds and the pale pink for the upper parts and petals of the rose flower and buds.

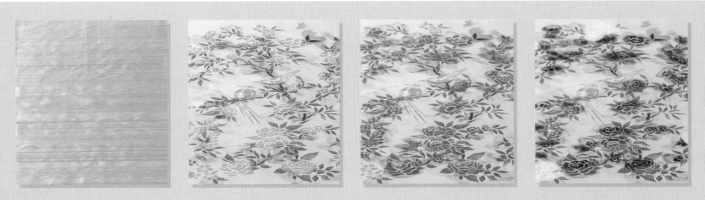

STAGE 1 **STAGE 2** **STAGE 3** **STAGE 4**

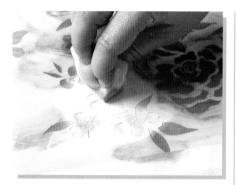

STEP 5

Now use the cerise–crimson to overstencil the tops and middles of the rose flowers and buds. Then stencil the simple five-petal flowers in white and add yellow centers to them.

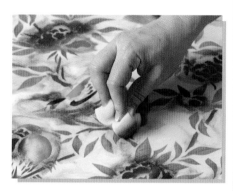

STEP 6

To stencil the birds and bugs, add some deep turquoise and purple to your palette and then stencil the butterflies' wings and birds' tails in purple and turquoise and the birds' wings, beaks, and chests in yellow and crimson. To complete this first section of stenciling, use the gold fabric paint to "blush" some gold highlights over the birds, the tree trunks, and some of the flowers.

STEP 7

Carefully peel away the upper stencil and then stick the bottom stencil section underneath the first, lining up the two registration dots at the top of this stencil section with the dots drawn on the fabric from the first section. Repeat the stenciling process, stenciling the branches, twigs, leaves, and roses in the same colors as before.

STEP 8

To stencil the hydrangea-type flowers of this section, first stencil the whole of the flower in white and then overstencil and blend in some purple fabric paint.

STEP 9

For the bird of paradise, stencil the wings and tail in a combination of purple and turquoise, adding yellow and gold to the chest, legs, and crest. Finally, stencil the lines and shapes on the ground level use a combination of blue and brown "blushed" with gold.

STEP 10

Repeat the whole of the stenciling process for the second panel, using the same colors but introducing a little more yellow and gold into the extra roses on this stencil. Let both panels dry, and then iron carefully on the reverse side with a hot iron. This makes the paint colorfast as well as removing creases.

STEP 11

To prepare the bamboo poles, use a ⅛ in. (5 mm) drill bit to drill a hole 1 in. (2.5 cm) from each end of the two top hanging poles.

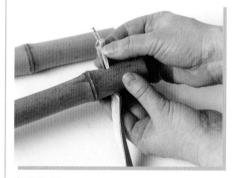

STEP 12

Thread the silk ties through the holes to make a 2 in. (5 cm) loop above the pole and knot the ties in a double knot beneath the pole. Tie the remaining four silk ties around the ends of the bottom poles as a decorative finishing touch. Thread the bamboo poles through the top and bottom gutters of the chinoiserie panels. Thread a dowel or long piece of bamboo through the loops and hang together.

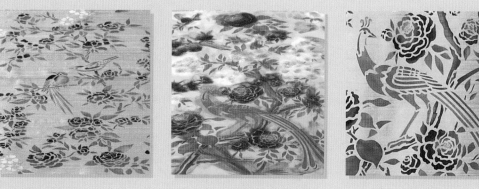

STAGE 5 STAGE 6 STAGE 7

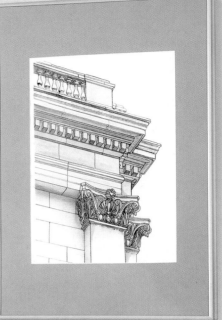

ARCHITECTURAL DETAIL

Beautiful architecture and its imagery will always inspire designers and decorators. Here classic themes and styles are adapted to suit current tastes, with inspiration drawn from a detail of a Turner watercolor, *Old Blackfriars Bridge*. The focus of these drawings is the classical elegance and beauty of pillars and columns and their Corinthian-style capitals. This project utilizes the benefits of modern technology to create the two enlarged architectural detail drawings, but you can also draw these images freehand either using the grid system outlined on page 13, or as an observational drawing.

PREPARATION: Use architectural details taken from prints in books or take your own photos of places that are of interest to you. The two drawings here utilize both of these sources, working with both digital and scanned images, but you can also follow these steps using color-photocopied images.

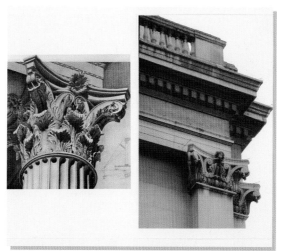

TOOLS & EQUIPMENT

39½ x 39½ in.
(100 x 100 cm)
(x2)

❏ Photographs or prints of architectural elements (see Dover Publications in Resource Directory, page 127)

❏ Fine felt-tip drawing pens

❏ Ruler

❏ Soft pencil

❏ Artist's sable brushes

❏ Oil crayon in terra-cotta or watercolor in burnt sienna and raw sienna

❏ Digital camera and access to computer and scanner or photocopier

STEP 1
From your selection of photographs or prints, choose two to develop as finished drawing. Scan the prints as JPEG images or, if you have taken your own photos, load the digital images into Photoshop (or similar computer program). Print the chosen images to fill an 11 x 8½ in. (A4) page. Alternatively, photocopy on photo-quality setting to this scale making sure the image is not too dark.

STEP 2
Use the felt-tip pen to draw over the main lines of the architectural features on the printed images. A combination of freehand and ruler-drawn lines works best for this. You can also extend elements of your prints as desired (as seen here in the Corinthian column).

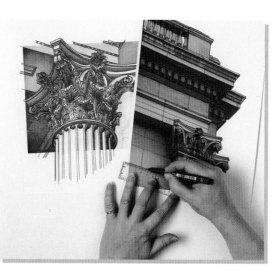

PHOTOGRAPHIC MATERIALS

SEE ALSO:
DRAWING TECHNIQUES, PAGE 12
PHOTOGRAPHIC TECHNIQUES, PAGE 23

STEP 3

Rescan the prints into the computer and load them into Photoshop as JPEG images. Most of the color and tone will now be removed from the images to create a light sepia effect. To do this, open the images and go to Image, Adjustment, and open the Brightness and Contrast window from the scroll-down menu. Every photograph will vary, but as a guide, bring the brightness up to 100 and the contrast up by 10–15.

STEP 4

Go to Image, Adjustment, and open the Hue/Saturation window. Reduce the Saturation by about 20. Apply this process to both images and save, name, and print the JPEG images enlarged to fit letter or A4 paper. Alternatively, photocopy the images on a light photo setting.

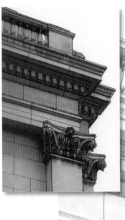

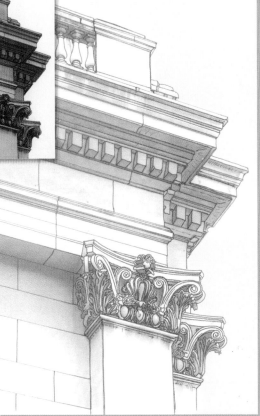

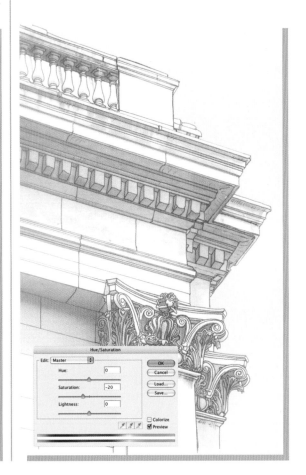

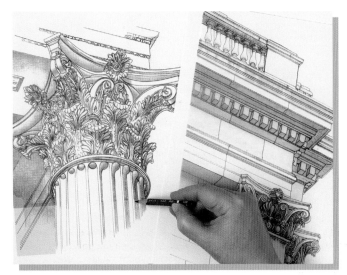

STEP 5

Take the newly printed images and use the felt-tip pen to re-emphasize some of the main lines of the drawing, working with a ruler and drawing freehand. Then use a soft drawing pencil to add and extend shaded areas, keeping the effect subtle and not too heavy or dark.

STEP 6

Take these images to have them professionally color
photocopied and enlarged onto high quality tabloid
size (A3) paper. Use the thickest card/paper that the
photocopier can manage.

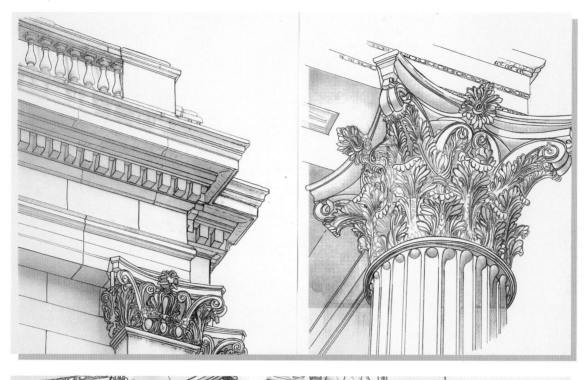

STEP 7

Finally, use either the oil crayon in terra-cotta or watercolor
in burnt sienna and raw sienna to add lightly shaded areas
or washes of color to enhance the slight sepia tint of the
images. Add shading to naturally shaded areas such as the
undersides of the different structures.

STEP 8

Mount the finished drawings in deep window mounts
of pale gray or sepia tint and then frame them with fine
wooden or aluminum frames with non-glare glass.

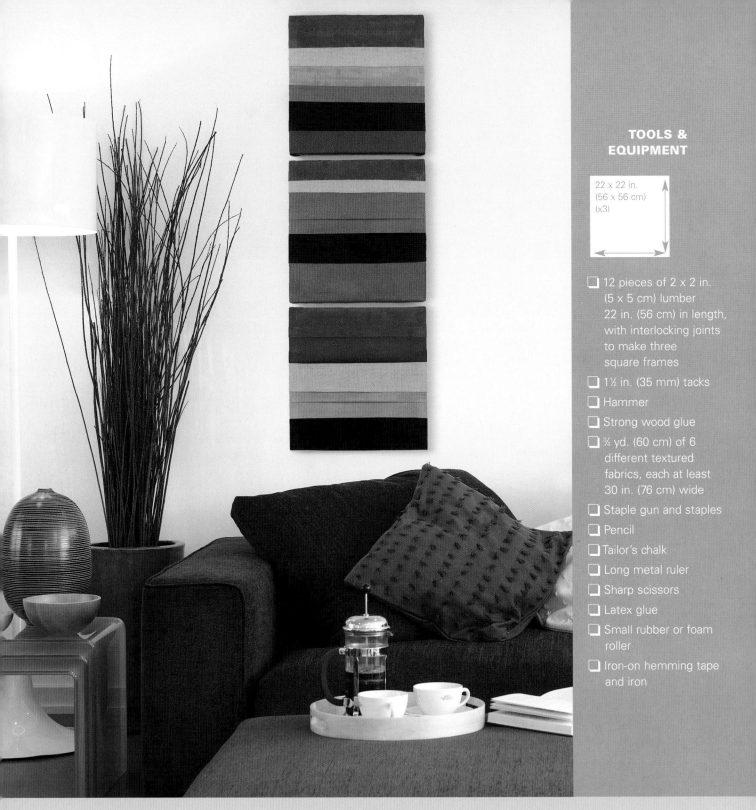

TEXTILE STRIPES

These simple textile panels utilize the effect of beautifully contrasting textured fabrics, including natural burlage or jute, corduroy, faux suede, and leather in different brown tones. If faux suede is not available, velvet fabrics are also suitable. The fabrics are stretched over three frames, which can be hung as a vertical or horizontal linear group. The order of the fabrics is up to you—you can use either a gradual transition of color or adjacent contrasting colors.

STEP 1

For the three wooden frames ask your local lumber suppliers to cut 2 x 2 in. (5 x 5 cm) lumber into 22 in. (56 cm) lengths with rabbeted joints that interlock to create the square frame. Use strong wood glue and the tacks to fix the pieces together, hammering the tacks into the overlapping recess and adjacent interlocking piece.

STEP 2

Cut the fabrics to approximately 26 in. (66 cm) wide, which includes an allowance for stretching the fabric around the sides of the frame and stapling on the back. Choose between a finished depth of 8 in. (20 cm) and 5 in. (13 cm), and add a 2 in. (5 cm) allowance for fabrics that fray because the exposed edge will need to be turned under.

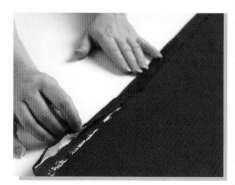

STEP 3

To prepare fabrics that fray, cut to your chosen dimensions and apply latex glue to the inside of both sides of the proposed fold. Fold over and stick down, then run the foam/rubber roller firmly along the fold for a crisp edge.

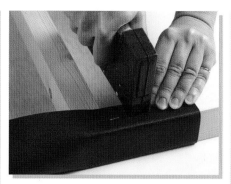

STEP 4

To stretch the fabric onto the wooden frame, lay the top end piece of fabric flat on the table, wrong side up, and center the frame onto it, leaving the 4 in. (10 cm) allowance at the top. Pull the fabric on the side of the frame opposite you around to the back of the frame and use the staple gun to fix it to the frame. Do not staple right up to the corner of the frame at this stage.

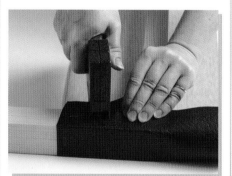

STEP 5

Turn the frame and fabric around and firmly pull the fabric on the other side, opposite you, around to the back of the frame and then staple it down securely. Do not staple right up to the corner.

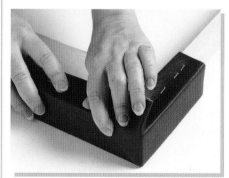

STEP 6

Pull the fabric on the top edge of the frame around to the back. Staple first in the middle and work out to both sides. Do not staple right up to the corners. To staple the corners, cut off the excess fabric and pull the fabric on the top edge down over the corner and staple. Pull the flap back over from the side to form a fold on the top edge of the frame. Staple.

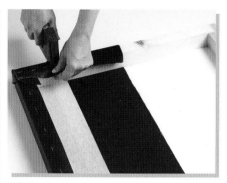

STEP 7

Now place the second piece of prepared fabric so that it overlaps the first (by approximately 1 in. (2.5 cm)) and is horizontal across the frame. Holding the fabric in place, carefully turn the frame over and staple both edges as before.

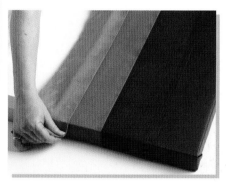

STEP 8

Continue stretching and fixing the different pieces of fabric over the frame. For the last piece of fabric along the bottom edge, follow the same techniques as in step 6 for the top of the frame.

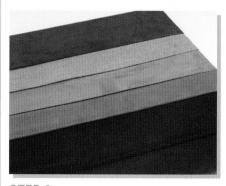

STEP 9

Remove any fluff or stray threads from the finished frame before hanging, then make up the two remaining panels to finish the set.

SEE ALSO:
TEXTILE TECHNIQUES, PAGE 22
HANGING AND LIGHTING WALL ART,
 PAGES 26–27

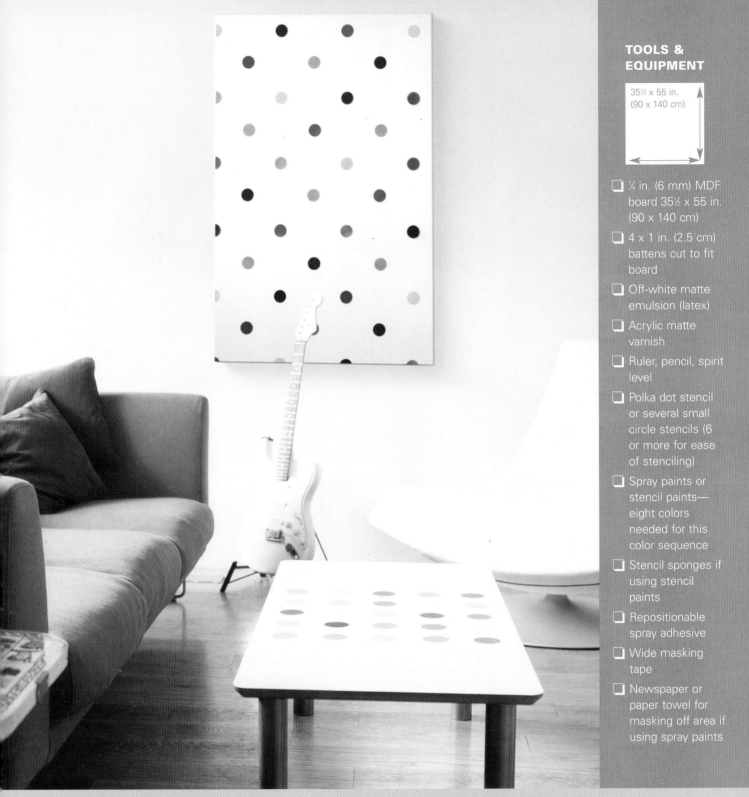

TOOLS & EQUIPMENT

35½ x 55 in. (90 x 140 cm)

- ❑ ¼ in. (6 mm) MDF board 35½ x 55 in. (90 x 140 cm)
- ❑ 4 x 1 in. (2.5 cm) battens cut to fit board
- ❑ Off-white matte emulsion (latex)
- ❑ Acrylic matte varnish
- ❑ Ruler, pencil, spirit level
- ❑ Polka dot stencil or several small circle stencils (6 or more for ease of stenciling)
- ❑ Spray paints or stencil paints—eight colors needed for this color sequence
- ❑ Stencil sponges if using stencil paints
- ❑ Repositionable spray adhesive
- ❑ Wide masking tape
- ❑ Newspaper or paper towel for masking off area if using spray paints

POLKA DOT CIRCLES

This is both fun and funky—a polka dot design inspired by some 1950s fabric and given a bright modern color application. Great for room spaces where you want to add a splash of color, or alternatively, use a muted palette. This versatile piece can be adapted to fit your mood, style, and color scheme, using either harmonizing or contrasting colors. This project can be stenciled in different ways or painted by hand —follow the project guidelines for your preferred method.

STEP 1

First make up the battened board following the instructions on page 9. Base paint the board with two coats of off-white matte emulsion, sanding between coats, and varnish with one coat of acrylic matte varnish.

STEP 2

Choose the color sequence of your polka dots—this can be any repeating sequence of eight colors. Some variations are shown above, but the sequence used in this project gives diagonally alternating colors.
Top row: yellow, purple, turquoise, yellow.
Second row: blue, green, red, orange.
Third row: pink, yellow, purple, pink.
Fourth row: orange, blue, green, red.
Fifth row: turquoise, pink, yellow, green.
Sixth row: red, orange, blue, green.
Seventh row: purple, turquoise, pink, purple.
Eighth row: green, red, orange, blue.
Repeat.

PAINTING BY HAND

This project can be done by hand with drawn and painted circles, although the circles will have more of a freehand look. Mark the board up with a grid and place circles on the alternating apex points of the grid. Draw the circles using a compass, or draw around a glass. Carefully fill in the circles using a sable brush to paint the outline and a fitch brush for filling the center. Paint as evenly as possible.

STEP 3

If you are using a polka dot stencil, follow these steps: Apply repositionable spray adhesive to the reverse side of the stencil and stick it securely to the top left side of the board, ensuring that the stencil is fully adhered. If you have a second stencil, stick it down directly underneath the first, ensuring that the registration dots on the stencil are lined up.

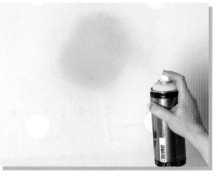

STEP 4

Use wide masking tape and newspaper or paper towel to protect the surrounding area, and use either stencil paint or spray paint to fill the first circle of the first row, yellow in this example.

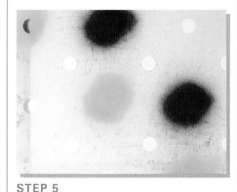

STEP 5

Stencil all of the same color circles. Follow this with the next color of the first row, stenciling all circles of this color, red in this example.

STEP 6

Continue this process until you have stenciled all of the circles with the colors, according to your chosen sequence.

STEP 7

Remove the repeat stencil and realign at the bottom of the board to complete the color sequence.

STEP 8

Finally, complete the sides in the same way as the bottom.

SEE ALSO:
PRINTMAKING TECHNIQUES, PAGE 18

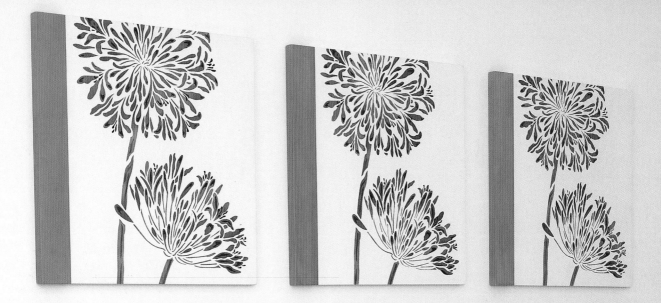

FLOWER BLOOMS

This simple project utilizes the stylish technique of repeating an image for an up-to-date contemporary look that is both beautiful and elegant. The graceful blooms of the agapanthus are stencilled here on three separate panels to create this stunning piece of wall art. This technique can be used equally successfully for different botanical images and for different colorways, adapted to suit your room style and color scheme.

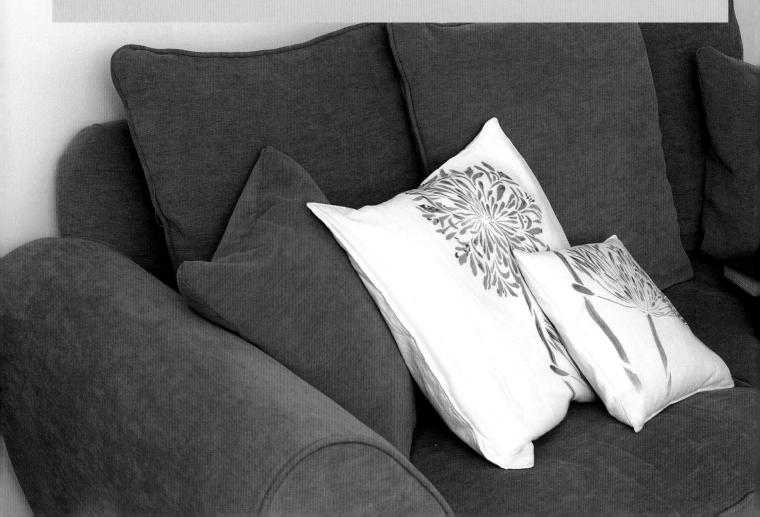

PREPARATION: Sand the top and sides of the MDF boards until smooth. Base paint with two coats of ivory matte emulsion (latex), sanding between coats to create a smooth surface. Use a tack rag to remove all traces of dust. Apply one coat of acrylic matte varnish to seal and protect.

TOOLS & EQUIPMENT

15 x 15 in.
(38 x 38 cm)
(x3)

❑ 3 x ⅞ in. (18 mm) MDF boards 15 x 15 in. (38 x 38 cm)
❑ Agapanthus stencil—see Resource Directory (or similar design)
❑ Ivory matte emulsion (latex)
❑ Sandpaper and tack rag
❑ Acrylic matte varnish
❑ Artist's medium fitch brush
❑ 2 in. (5 cm) painting tape or masking tape
❑ Pencil and ruler
❑ Paper plate or divided palette
❑ Stencil sponges and kitchen towel
❑ Repositionable spray adhesive
❑ Stencil paints in medium and dark purple, medium and dark blue, sage and leaf green
❑ Lilac metallic or interference paint

PROJECT MATERIALS

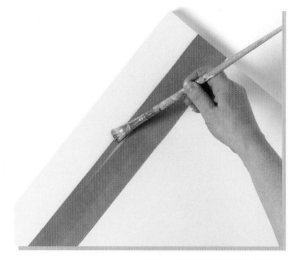

STEP 1
Make a series of light pencil registration marks 2 in. (5 cm) from the left edge of each board. Then stick a strip of painting tape along the outer edge of the marks on each board. Use the artist's fitch brush to apply a thin layer of acrylic matte varnish along the left edge of the tape—this will prevent paint from bleeding under this edge, thus creating a sharp edge.

STEP 2
Use the medium purple stencil paint or similar matte emulsion color to paint a 2 in. (5 cm) band on the left edge of each board, inside the tape. Leave to dry, and then apply a second coat. Once this has dried, apply a fine overlayer of lilac metallic or interference paint. Carefully peel away the painting tape.

STEP 3
Apply repositionable spray adhesive to the reverse side of the first layer of the agapanthus stencil (or similar flower design). Stick the main flower section of the design on the first board to the right of the painted purple band. Smooth your hand over the design to make sure all cut-out shapes and bridges are fully stuck down.

STEP 4

Use the medium purple stencil paint to stencil some of the flower shapes of the agapanthus heads. Work with a nearly dry sponge, and then over-stencil a second and third time to build up depth and opacity of color. Use the medium blue stencil paint to stencil the remainder of the flower shapes in the same way.

STEP 6

Use the medium purple to overstencil and blend the blues and purples on the flower heads. Add a few highlights with the lilac metallic or interference paint. Carefully peel away the stencil, and repeat the same process on the remaining two boards.

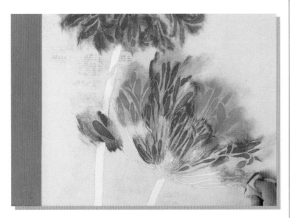

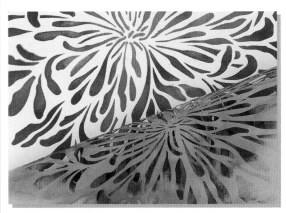

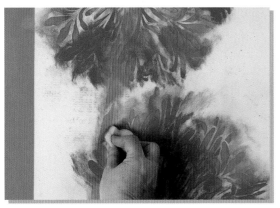

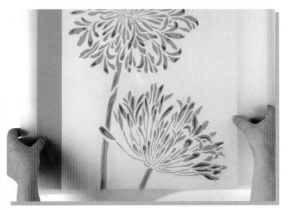

STEP 5

Use the sage green stencil paint to stencil the main flower stems and the stems within each flower head. Then add tonal variation to the stems with the leaf green and a little purple and blue stencil paint "blushed on" in places.

STEP 7

Apply repositionable spray adhesive to the reverse side of the second layer of the stencil and position over the first layer, lining up the flower stamens and stalk details within the stenciled shapes of the first layer.

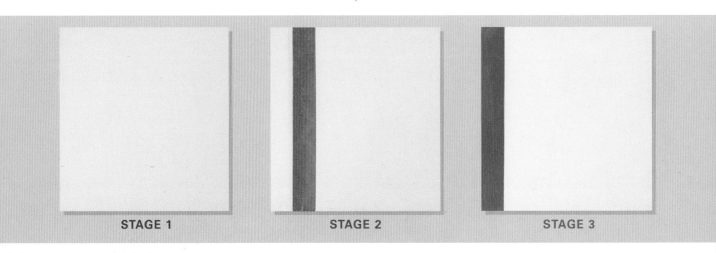

STAGE 1 **STAGE 2** **STAGE 3**

STEP 8

Use the dark purple and blue stencil paints to stencil the flower stamens, building up depth of color by repeated layering as before. Also add darker green and purple to the stems. Repeat the process on the remaining two boards, and leave them to dry.

STEP 10

Drill a hole ¼ in. (6 mm) deep into the board. You will need to make two holes at the top of each board. Use a drill bit that is wide enough to drill a hole slightly larger than the diameter of the screws you will be using in the wall.

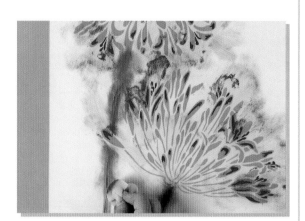

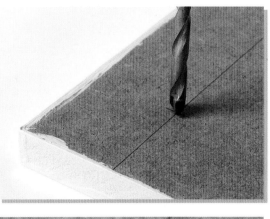

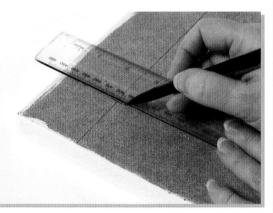

STEP 9

To hang the three boards, use a ruler and pencil to mark up two points on the back of each board, positioned 2 in. (5 cm) in from each side edge and from the top of the board.

STEP 11

Position the three completed boards so that they hang in a horizontal row with about a ½ in. (1 cm) gap between each board. Position, mark up, and fix the six screws to hang the boards accordingly.

STAGE 4

STAGE 5

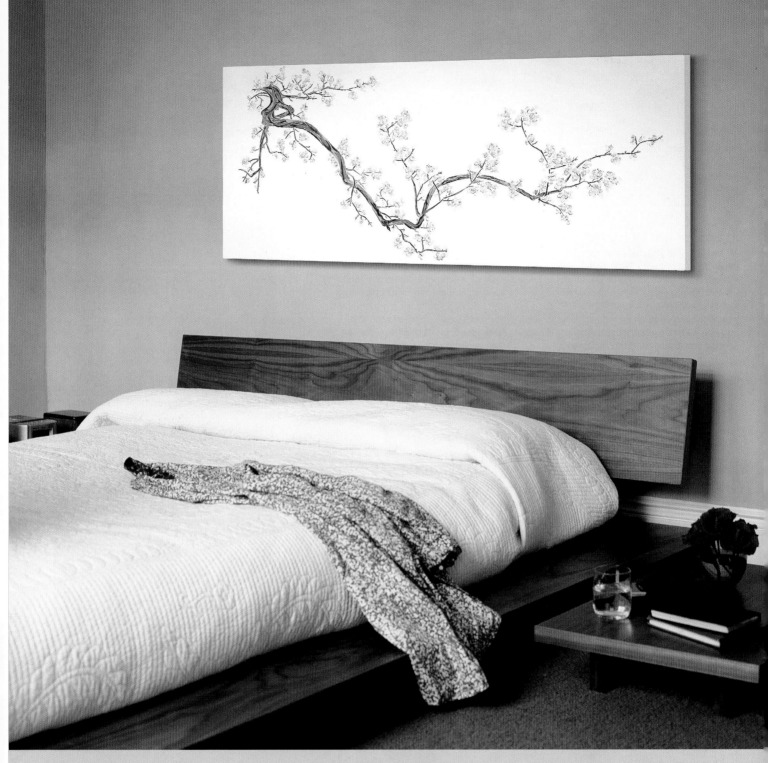

BLOSSOM BOUGH

The restful, modern qualities of this Japanese-inspired piece—a bough of delicately painted spring cherry blossom on a background of palest sky—make it a perfect backdrop for bedroom spaces and quiet places, and its wide horizontal dimensions are ideal for hanging above beds. Each painting step is laid out to enable beginners and professionals alike to create this elegant piece inspired by the art of Japanese blossom painting.

Preparation: Make up a battened board (see page 9). Apply two coats of white or gray emulsion, sanding between coats, and then one coat of varnish. Mix about 3 fl oz. (100 ml) of water-based glaze (see page 16), put a little aside, then tint the rest with 2 to 3 drops of cobalt blue and 4 drops white tint colorant to make a pale sky blue. Apply a few mottled patches with a dampened sea sponge and soften with a badger softener (see page 17). Allow to dry. Tint the remaining glaze with white, and apply around and over the blue patches to create a soft cloud effect. Once dry, apply a coat of acrylic matte varnish.

TOOLS & EQUIPMENT

21½ x 53 in.
(55 x 135 cm)

- ❏ ¼ in. (6 mm) MDF board 21½ x 53 in. (55 x 135 cm)
- ❏ 1¼ in. (3 cm) battens to fit the board
- ❏ Off-white or very pale gray matte emulsion (latex)
- ❏ Cobalt blue and white universal tint colorants or artist's acrylic
- ❏ Acrylic scumble glaze
- ❏ Acrylic matte varnish
- ❏ Fine natural sea sponge
- ❏ Badger softener (or other soft brush)
- ❏ Blossom prints and sketches
- ❏ Pen, pencil
- ❏ Masking tape
- ❏ Blue wax-free transfer paper
- ❏ Light brown and pale pink emulsion or decorative paint
- ❏ Medium and fine artist's sable brushes
- ❏ Damp cloth
- ❏ Artist's acrylics (white, burnt umber, raw umber, cadmium red, raw sienna, Hooker's green, cadmium yellow)

STEP 1
Create a drawing of blossom by tracing outlines from your collected prints, then have it professionally photocopied and enlarged to fit the board. Lay a large sheet of blue transfer paper face down onto the left-hand side of the board and lay the enlarged drawing over it and tape it into place. Use a pencil or ballpoint pen to trace over the drawing to transfer the outline onto the glazed board.

STEP 2
Move the blue transfer paper along and continue until the whole outline has been transferred onto the board.

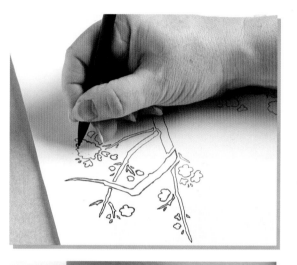

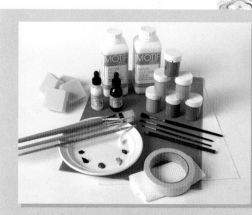

PROJECT MATERIALS

SEE ALSO:
DRAWING TECHNIQUES, PAGE 12
SCALING UP AND TRANSFERRING DESIGNS, PAGE 13
PAINTING TECHNIQUES, PAGE 14

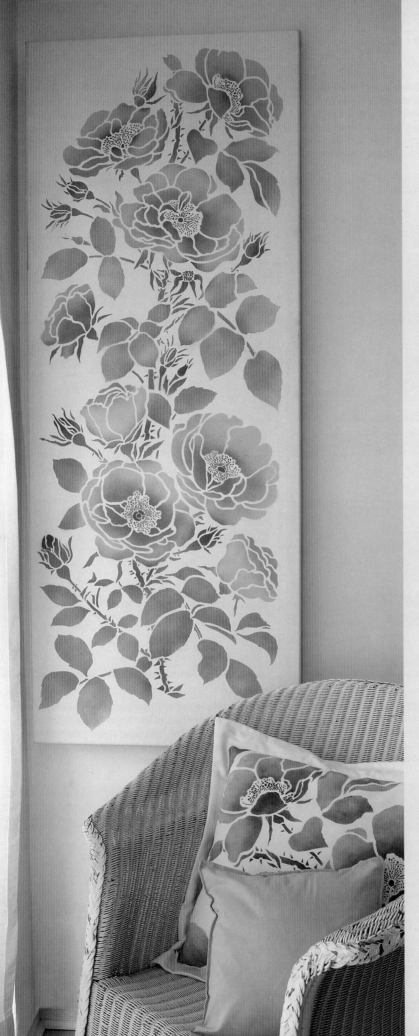

WILD ROSE STENCIL

The simplicity of a large natural canvas and oversized wild rose stencil combine here to create a striking and beautiful piece of wall art, perfect for creating elegant, modern shabby chic style —ideal teamed with painted furniture, floorboards, bare walls, and softly tailored furniture.

TOOLS & EQUIPMENT

23½ x 59 in.
(60 x 150 cm)

- ❏ 39 in. (100 cm) of pre-primed canvas 6 ft. (1.8 m) wide (alternatively, plain cotton duck and acrylic primer to prime)
- ❏ 1 pair artist's stretchers 59 in. (150 cm)
- ❏ 1 pair artist's stretchers 23½ in. (60 cm)
- ❏ 1 support bar 23½ in. (60 cm)
- ❏ Oversize Rose stencil (see Resource Directory) or similar large stencil
- ❏ Repositionable spray adhesive
- ❏ Spray paint colors: raw sienna, rose pink, soft red, white, burnt sienna, crimson, dark green, leaf green, pale green, gray
- ❏ Large sheet of paper for masking off
- ❏ Fine artist's sable brush
- ❏ Pale cream paint for touch ups

PREPARATION: Stretch the pre-primed canvas or plain cotton duck onto the stretchers (follow the instructions on page 10). Hang securely on a wall at a good working height, or work on an artist's easel.

STEP 1
Apply repositionable spray adhesive liberally to the back of the first section of the Oversize Rose stencil (or similar large stencil) and align the stencil to sit squarely at the top of the canvas, with the top of the design placed 1 in. (2.5 cm) from the top of the canvas. Smooth over the stencil to ensure that every cut-out shape is properly adhered, so no paint bleeds under the stencil. Put paper below the stencil to protect the lower section of the canvas from stray spray paint.

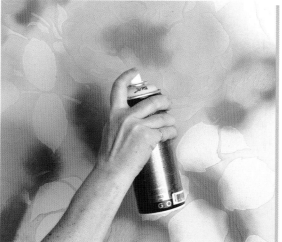

STEP 2
Use the spray paints following the manufacturer's guidelines (see Tip box on page 101). Spray raw sienna to stencil the stalks, thorns, and flower stamens. Build up two or three layers of paint to these areas and then use the rose pink spray paint to stencil the rose flowers and buds, building up two layers.

SEE ALSO:
STRETCHING A CANVAS, PAGE 10
PRINTMAKING, PAGE 18

PROJECT MATERIALS

STEP 5
Use the dark green to stencil the large leaf shapes, then over-spray with the brighter leaf green and blend with the pale green spray on the leaf shapes. Finally, use the gray to soften and knock back the greens.

STEP 3
Use the soft red to spray the inner petals of the main rose flowers and the center of the buds. Use white spray paint to soften and blend the pink and red together, and then burnt sienna to over-spray the flower stamens.

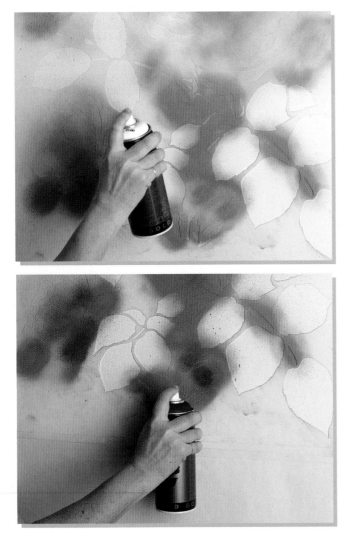

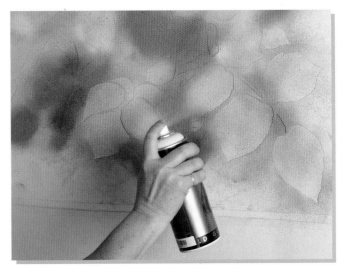

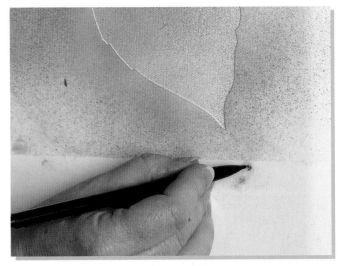

STEP 4
Apply the crimson to highlight parts of the buds and some large rose petals and use the pale pink to soften the effect as necessary. The blending and mixing of colors adds to the overall subtle effect of this technique.

STEP 6
Use a pencil to lightly mark through the registration dots at the bottom corners of the stencil.

STENCILING ON CANVAS

Spray paints make it easier to cover the cut-out areas of large stencil designs and are ideal for stenciling onto stretched fabric. Follow these tips for best usage:

Shake the can thoroughly before use, then spray onto some newspaper to release the spray.

Hold the can about 10 in. (25 cm) away from the stencil area and start to spray. Move the can closer for finer detailed work.

Release blockages by shaking, turning the can upside down, and pressing the nozzle.

If you prefer to use stencil paints for this project, stencil onto the canvas first and then stretch it onto canvas stretchers when dry (canvas on stretchers has a "bounce" to it, making stenciling by hand difficult). Alternatively, stencil onto a battened board.

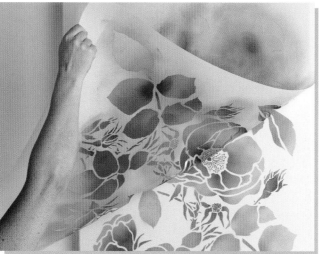

STEP 7
Carefully peel away the stencil and remove the lower protective sheet.

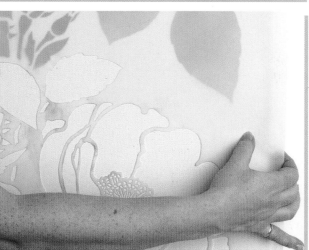

STEP 8
Apply repositionable spray adhesive to the reverse side of the second section of the stencil and line up the registration dots at the top of the stencil with the marks made at the bottom of the first stencil print, ensuring that the stencil sheet is vertical and adhered completely.

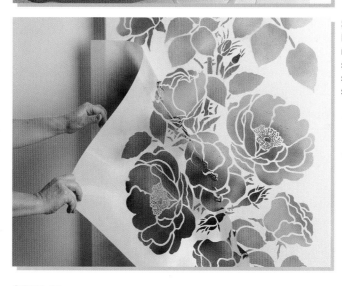

STEP 9
Follow steps 2 to 5, repeating the spray stenciling process in the same order to create the same colors and effects.

STEP 10
Finally, use a fine sable brush and a pale cream paint, the same color as the canvas base color, to paint out any paint smears, smudges, or bleeds, as well as the pencil registrations dots.

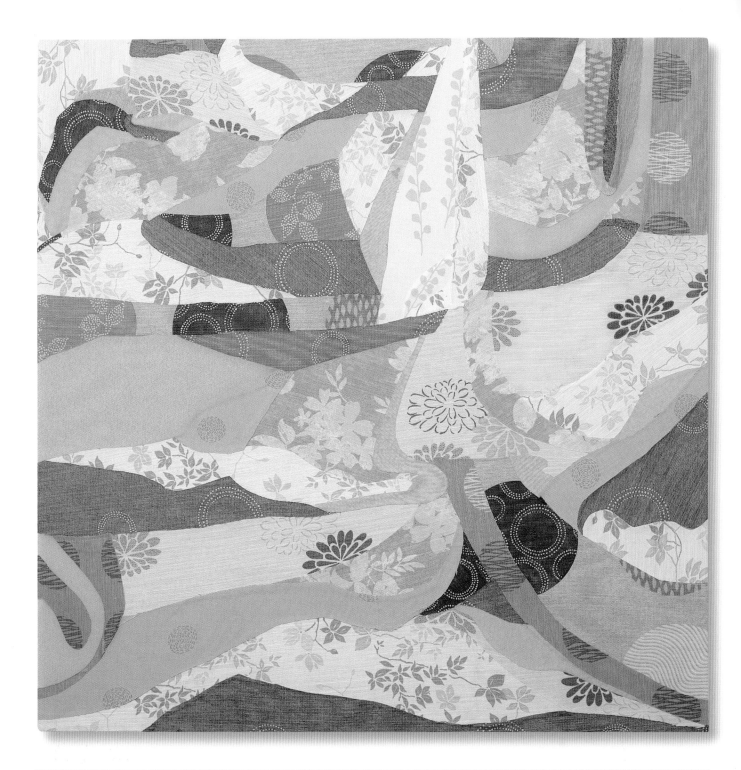

KIMONO FOLDS

This modern textile collage has a restful feel and sets a quiet, neutral tone. It is an abstract design based on the folds of traditional Japanese kimono sleeves, layered skirts, and obis, translated into a fabric collage made of contemporary, Japanese-styled textiles. The collage can be adapted to any chosen color scheme, using the existing fabrics of a room or fabrics that are part of a planned soft furnishings theme.

TOOLS & EQUIPMENT

39½ x 39½ in. (100 x 100 cm)

- ❑ ¼ in. (6 mm) MDF board 39½ x 39½ in. (100 x 100 cm)
- ❑ 1 in. (2.5 cm) batten cut to fit board
- ❑ Prints and pictures of Japanese ladies and kimonos
- ❑ 20 in. (51 cm) each of 6 or 7 different patterned and plain upholstery fabrics
- ❑ Permanent spray adhesive or latex glue
- ❑ Ruler
- ❑ Sharp paper scissors
- ❑ Pencil, felt-tip pen, ballpoint pen
- ❑ Paper
- ❑ Tracing paper
- ❑ Layout paper:
 (U.S.) Arch C (18 x 24 in. [457 x 610 mm]) paper
 (U.K.) A2 (16.5 x 23.3 in. [420 x 594 mm]) paper
- ❑ Blue wax-free transfer paper

PROJECT MATERIALS

PREPARATION: To make the collage design, first make a series of drawings by tracing the outlines of the Japanese ladies and their kimonos from the prints you have collected. Photocopy the tracings and cut out sections that show the folds of the clothing. Place in interlocking and adjacent positions to make up a paper collage. Glue the pieces together onto some backing paper (approx. 17 in. [43 cm] square). Tape a piece of layout paper over the collage and use a felt-tip pen to trace the outline of the shapes. Keep the design simple. Have the drawing professionally photocopied and enlarged to fit the MDF board.

STEP 1

Prepare the square battened board following the instructions on page 9. Lay a sheet of transfer paper face down onto the bottom left-hand corner of the board, then tape your enlarged paper template over it. Use a ballpoint pen to trace over the template, pressing firmly to transfer the outline onto the underlying MDF board. Move the transfer paper to the right and continue the process, moving around the board until the entire outline has been transferred.

SEE ALSO:
TEXTILE TECHNIQUES, PAGE 22
SCALING UP AND TRANSFERRING DESIGNS, PAGE 13

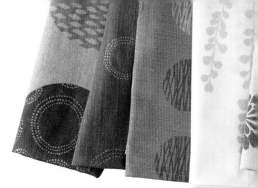

STEP 2

Number all of the sections of the enlarged paper template and mark the corresponding numbers clearly onto the board. Draw an outward pointing arrow on the template pieces that are on the edge or corner of the board—the arrow will signify that you need to add an excess of 2 in. (5 cm) on this edge for wrapping around the edge of the board.

STEP 4

Lay the template piece onto the right side of the fabric. Pin near to the edge and cut out. (Ensure the raw edges are neat as they will be stuck down directly without hemming.) For any edge or corner pieces, allow an extra 2 in. (5 cm) of fabric. Mark the pattern piece number on the reverse.

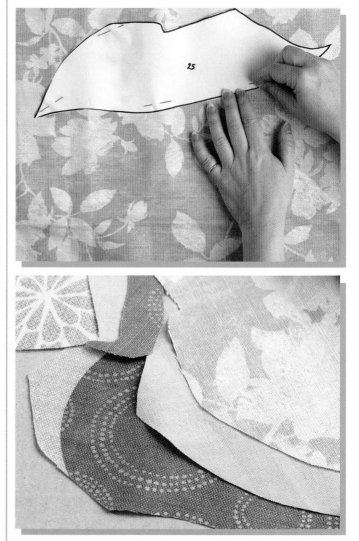

STEP 3

Choose which section of the collage to start with—this can be an edge or the middle. Use sharp scissors to cut out some of the shapes from the enlarged paper template, working a section at a time to avoid losing any template pieces.

STEP 5

Lay each successive piece of fabric onto the board in the relevant position—this prevents any pieces from being lost and gives an idea of which fabric pattern to use as you go. Try to keep similar fabric patterns separate within the design. Once you have laid out a number of pieces, start to adhere them.

STEP 6

To stick corners, apply glue to the entire reverse side of the piece of fabric and then lay it down so that it lines up with the shape on the board, with the 2 in. (5 cm) allowance hanging over the edge. Fold the fabric under the corners in an "envelope" style, cutting off excess fabric.

STEP 8

As you work, check that the board is being covered fully by the cut-out pieces—adjust the sizes of pieces as necessary in order to fill any gaps.

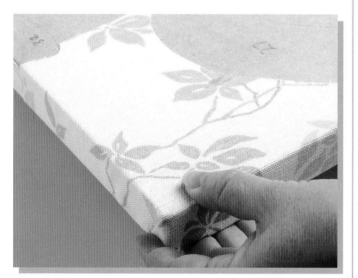

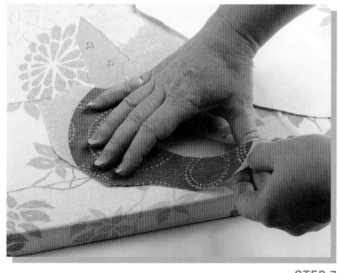

STEP 7

Continue sticking down the fabric pieces, one by one, working a section at a time until the entire board has been covered.

STEP 9

On completion, check that all fabric pieces on the front of the board and the pieces wrapped around the sides have been adhered fully, and use a small pair of sharp scissors to remove any stray threads.

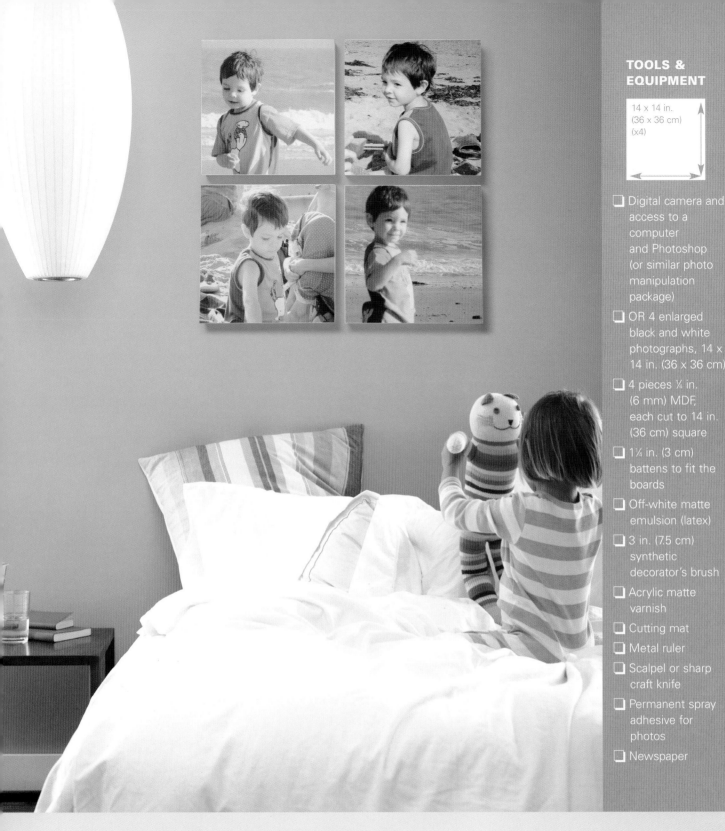

CHILD PORTRAITS

Use this simple technique to create an outstanding family portrait for bedroom, playroom, or living room walls, in atmospheric black and white. Use a selection of personal photos to create a modern portrait montage by enlarging your chosen photos and mounting them onto four battened boards, which give a solidity and depth to the images.

STEP 1
Take a selection of photos of your family. If you are using non-digital photography, ask your film processors to create a contact sheet so you can choose which photos to use. Ask for 14 in. (36 cm) square, black and white reproductions of your chosen shots. For non-digital images, begin at Step 5.

STEP 3
Go to Image, Adjustments, and open the Brightness and Contrast window from the scroll-down menu. Alter the brightness and contrast to bring out the depth of the image. Make sure the image is light/bright enough, but do not over-brighten. Save and name the JPEG images.

STEP 4
To resize the images into the 14 in. (36 cm) square format, you can enlarge the photos in the Print Preview window or preferably use the resizing technique described in the Photographic Art project, pages 72–75, Steps 6 and 7. Aim to keep all of the head sizes at approximately the same scale, which will give an overall uniformity to the photomontage. Burn the saved images onto a DVD or CD-ROM and take to your film processing company for production. Ask for your images to be printed on good quality paper to give the best reproduction.

STEP 6
Use a cutting mat, metal ruler, and sharp craft knife to cut off the white borders on the enlarged photographs. Check that the images fit the boards and trim as necessary. Lay each photo face down on several sheets of newspaper. Spray a permanent photo adhesive from left to right across the back of the photo, holding the spray nozzle at a distance of 8 in. (20 cm). Then spray up and down across the back of the photo.

STEP 7
Position the photo carefully so that the top of the photo lines up flush with the top of the board. Once positioned correctly, lay the photo down onto the board from top to bottom, smoothing each section down as you work down the length of the board. Smooth over the entire photo to ensure it is adhered completely. Repeat for each photograph.

STEP 8
Hang in a block of four (see instructions for hanging, page 26).

STEP 2
For digital images, load the shots onto your computer and open the JPEG images in Photoshop (or similar software program). Once open, go to Image (across the top of the screen), click on Adjustments, and then choose Desaturate from the scroll-down menu. This will convert color images to black and white.

STEP 5
Make up the four square battened boards (follow the instructions on page 9). Paint the boards with an off-white matte emulsion, sanding between coats for a smooth finish. Once dry, apply a coat of acrylic matte varnish and allow to dry thoroughly.

BUTTERFLY SKY

Follow the steps for Butterfly Sky to create an imaginative, charming, and beautiful piece, perfect for girls' rooms and nature lovers alike. The blue azure background is decorated with flying butterflies, and then a delicate butterfly mobile is suspended in front. Every little girl's favorite glitter paint is used to add extra shimmer and sparkle, beautiful in all sorts of different lighting.

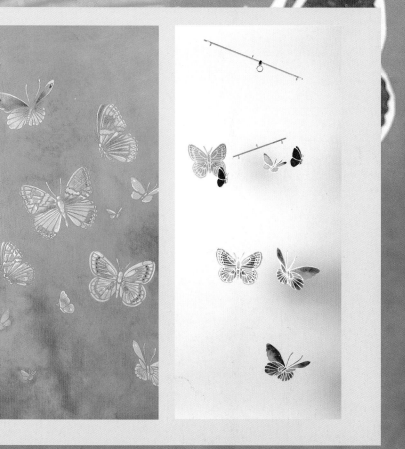

SEE ALSO:
PRINTMAKING, PAGE 18
GLAZE WORK TECHNIQUES, PAGE 16

TOOLS & EQUIPMENT

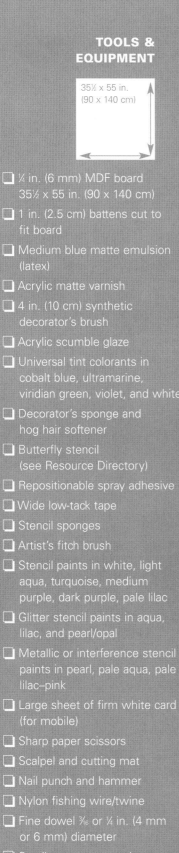

35½ x 55 in.
(90 x 140 cm)

- ¼ in. (6 mm) MDF board 35½ x 55 in. (90 x 140 cm)
- 1 in. (2.5 cm) battens cut to fit board
- Medium blue matte emulsion (latex)
- Acrylic matte varnish
- 4 in. (10 cm) synthetic decorator's brush
- Acrylic scumble glaze
- Universal tint colorants in cobalt blue, ultramarine, viridian green, violet, and white
- Decorator's sponge and hog hair softener
- Butterfly stencil (see Resource Directory)
- Repositionable spray adhesive
- Wide low-tack tape
- Stencil sponges
- Artist's fitch brush
- Stencil paints in white, light aqua, turquoise, medium purple, dark purple, pale lilac
- Glitter stencil paints in aqua, lilac, and pearl/opal
- Metallic or interference stencil paints in pearl, pale aqua, pale lilac–pink
- Large sheet of firm white card (for mobile)
- Sharp paper scissors
- Scalpel and cutting mat
- Nail punch and hammer
- Nylon fishing wire/twine
- Fine dowel ³⁄₁₆ or ¼ in. (4 mm or 6 mm) diameter
- Small screw eyes and round-pointed screwdriver or bradawl
- White capped drawing pins or curtain hooks or clips

PREPARATION: The first stage of this project can be applied directly to the wall or onto a battened board (see page 9). Base paint the wall or board with two coats of medium blue matte emulsion, sanding between coats. Varnish with one coat of acrylic matte varnish. Mix 1 pint (500ml) of water-based glaze (see page 16). Divide into three containers.

STEP 1

Tint the three glazes as follows: One turquoise using cobalt blue and viridian green tint colorants; one rich blue using ultramarine, cobalt blue, and violet tint colorants; and one white using white tint colorant. Apply each glaze using the colorwash technique (page 17), allowing each glaze to dry thoroughly before applying the next. Once dry, varnish with one coat of acrylic matte varnish and allow to dry for 24 hours. This project can be simplified by leaving the background as a flat base color.

STEP 2

Pour some dark purple, medium purple, light aqua, turquoise, and white stencil paints into a divided palette, along with some aqua, lilac, and pearl glitter stencil paints. Use the following stenciling instructions for all of the butterfly motifs, varying the color sequence, but keeping to the same color palette for a unified effect.

STENCILING MATERIALS

STEP 3

Apply repositionable spray adhesive to the reverse side of the large butterfly stencils and stick them close to each other at differing angles on the board or wall. Arrange the butterflies to look like a group fluttering across the space, as you add the different sized and angled stencils. Mask off the stencil edges with wide low-tack tape to prevent paint from smudging over the edges.

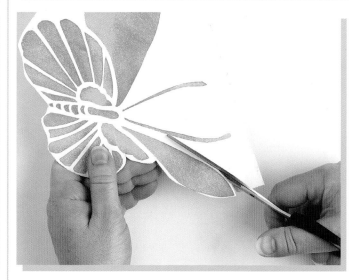

STEP 4

Follow steps 4 and 5 for each butterfly, varying the color sequence of the stenciling. Using stencil sponges, first stencil each butterfly entirely with white (as a base color). Then stencil the inner wings with light aqua; the outer wingtips and pattern markings with medium purple; and the circular markings with dark purple, using a small sponge or fitch brush for more direct application. Then use turquoise and light aqua to over-stencil parts of the wings to blend colors together and add depth and shading.

STEP 6

Now add the smaller butterfly motifs in and around the already stenciled motifs, repeating the stenciling steps above

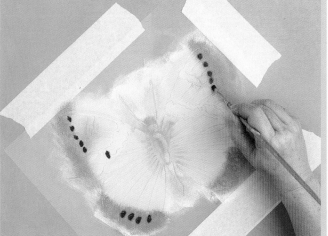

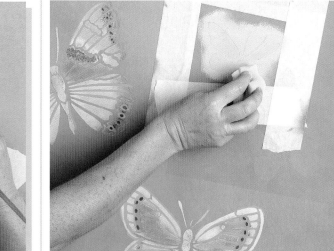

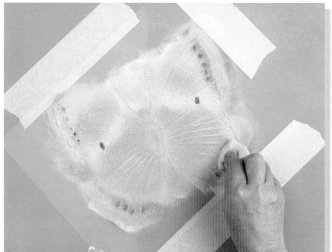

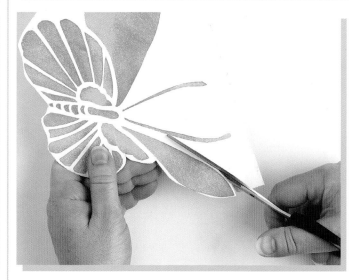

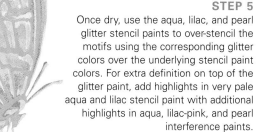

STEP 5

Once dry, use the aqua, lilac, and pearl glitter stencil paints to over-stencil the motifs using the corresponding glitter colors over the underlying stencil paint colors. For extra definition on top of the glitter paint, add highlights in very pale aqua and lilac stencil paint with additional highlights in aqua, lilac-pink, and pearl interference paints.

STEP 7

To make the butterfly mobile, first stencil the butterflies onto one side of the card using the medium purple and turquoise stencil paints. Stencil 6 pairs of butterflies (12 in total). Add highlights in aqua and/or lilac glitter stencil paints. Allow to dry. Cut out the butterflies using a pair of sharp scissors. Use a scalpel to neaten the edges. Repeat the stenciling process on the reverse side.

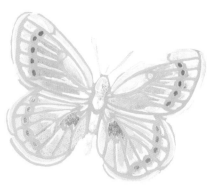

STEP 8

To construct the mobile, place each finished butterfly on a cutting mat and use a nail punch and hammer to punch a hole into the butterfly at its central point. The central point will vary from butterfly to butterfly—for a butterfly with symmetrical wings it will be between the antennae, but for butterflies that appear in profile, the point will be on one of the wings.

STEP 10

When you are ready to hang the mobile, thread the butterflies through the two screw eyes on each piece of dowel. Use the same butterflies for each pair or similarly weighted butterflies so that the mobile hangs straight and evenly.

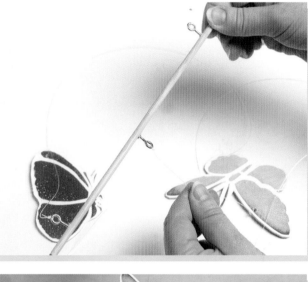

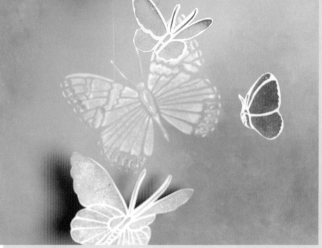

STEP 9

Thread the nylon thread through the punched holes and tie securely. Repeat for all six pairs of butterflies. Cut six lengths of fine dowel to varying lengths from 8 in. (20 cm) to 20 in. (51 cm)—the different lengths ensure that the butterflies hang at different widths. Use the screwdriver or bradawl to make a small hole in each end of the dowel (at the same angle) and then screw the small screw eyes into the holes. Fix a small screw eye in the top center of each piece of dowel and thread some nylon twine through this.

STEP 11

To hang, either fix each individual pair to the ceiling tied to a white-capped straight pin, or attach each pair to an extra length of dowel with curtain hooks or clips. Once you are happy with the position of the butterflies, hang the mobile in front of the Butterfly Sky.

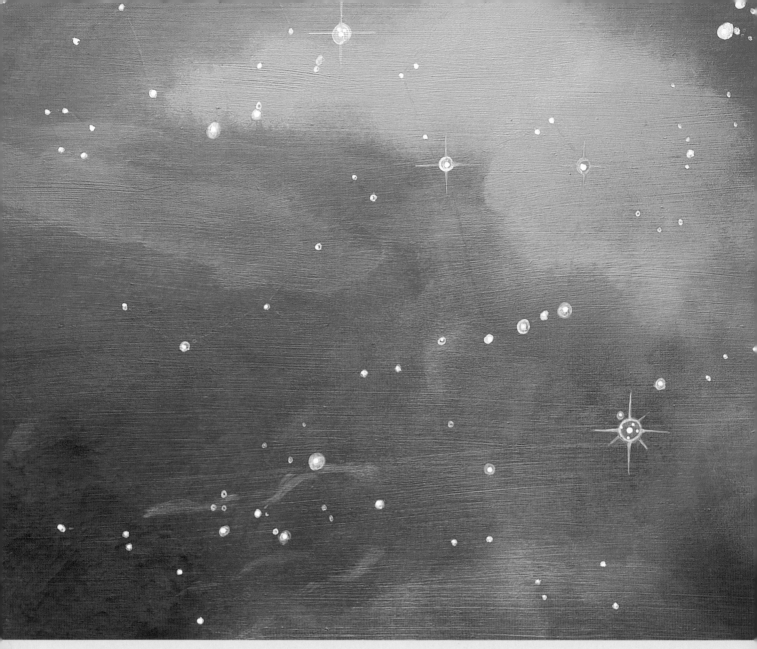

STARSCAPE

This is wall art at its most versatile—a beautiful stellar landscape that works as a painting in its own right or lit from behind. It is perfect for boys' rooms or night-sky gazers. This piece utilizes reflective interference paints, delicate hand painting, a fine drill bit, and glow in the dark paint! You can personalize this piece by your choice of

star constellations—such as the winter sky or spring sky, or the constellations that match the birth signs of your family, or those linked to the stories of Greek mythology. A delicate nebula forms part of the background here.

Preparation: If you want to undertake only the painting part of this project it can be worked directly onto the wall, but if you choose to drill the constellations and light from behind, first make up a battened board (see page 9) to cover the area being decorated. The board will be hung in front of lighting on a wall or ceiling. Base paint the board or wall with two coats of medium blue matte emulsion, sanding between coats. Varnish with one coat of acrylic matte varnish.

TOOLS & EQUIPMENT

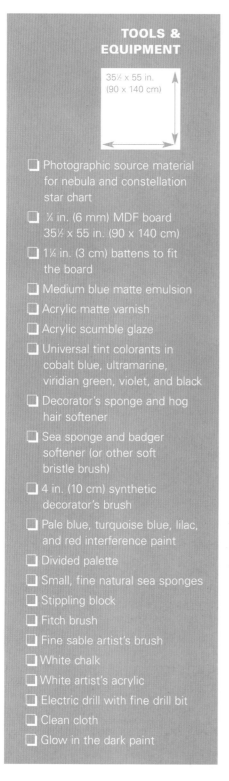

35½ x 55 in.
(90 x 140 cm)

- ☐ Photographic source material for nebula and constellation star chart
- ☐ ¼ in. (6 mm) MDF board 35½ x 55 in. (90 x 140 cm)
- ☐ 1¼ in. (3 cm) battens to fit the board
- ☐ Medium blue matte emulsion
- ☐ Acrylic matte varnish
- ☐ Acrylic scumble glaze
- ☐ Universal tint colorants in cobalt blue, ultramarine, viridian green, violet, and black
- ☐ Decorator's sponge and hog hair softener
- ☐ Sea sponge and badger softener (or other soft bristle brush)
- ☐ 4 in. (10 cm) synthetic decorator's brush
- ☐ Pale blue, turquoise blue, lilac, and red interference paint
- ☐ Divided palette
- ☐ Small, fine natural sea sponges
- ☐ Stippling block
- ☐ Fitch brush
- ☐ Fine sable artist's brush
- ☐ White chalk
- ☐ White artist's acrylic
- ☐ Electric drill with fine drill bit
- ☐ Clean cloth
- ☐ Glow in the dark paint

PAINTING MATERIALS

STEP 1

Tint ½ pint (250 ml) of acrylic matte varnish with the tint colorants—6 drops ultramarine, 6 drops cobalt blue, 10 drops violet, and 5 drops of black tint colorant, to make a dark transparent varnish. Use the decorator's brush to apply the varnish in wide strokes across the board, then use a hog hair softener working in crisscross strokes to soften the varnish. Allow to dry, then apply a second coat of the tinted varnish using the same technique. Leave to dry overnight.

STEP 2

The next stage is to create the nebula, an area of softly swirling colors that will sit behind the star constellations. This can be realistic or a fantasy nebula, but some photographic source pictures will help get you started. The nebula is best placed near the center of the glazed board and should be placed where you plan to overlay the main constellation of your star chart. Pour a little of each color of interference paint into a divided palette and dampen some small fine sea sponges.

SEE ALSO:
GLAZE WORK TECHNIQUES, PAGE 16
PAINTING TECHNIQUES, PAGE 14
SCALING UP AND TRANSFERRING DESIGNS, PAGE 13

STEP 3

Apply pale blue interference paint with the sponge and use the stippling block to spread the paint, so just a fine veil of color remains. Add patches of the other colors in the same way. Apply areas of more definite color with a sponge, fitch brush, or your fingertip and soften with the badger softener. Build a concentration of red near the middle of the nebula effect.

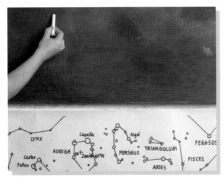

STEP 4

To create an enlarged constellation chart, trace your chosen chart from a book of constellation charts. Scan or photocopy the tracing, then enlarge on a photocopier to the size of your decorated background. Attach the chart below the background and use white chalk to lightly plot out the stars and constellations. You can rub out any errors as you go—the chalk will not leave marks on the glaze.

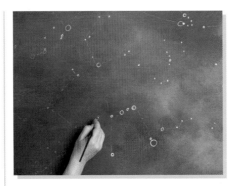

STEP 5

As you draw, use small circles for the stars (varying the size to match the sizes depicted on your enlarged chart), and faint dotted lines for the lines that run between stars representing the constellations. Use white artist's acrylic paint and a fine sable brush to paint over the circles of the stars, but don't paint the dotted lines at this stage.

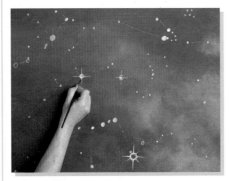

STEP 6

Add some starshine spikes to some of the larger stars and main points of different constellations.

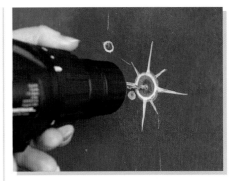

STEP 7

Once the paint is dry, use an electric drill fitted with a fine drill bit to gently drill small holes through the centers of the larger stars that make up the main constellations.

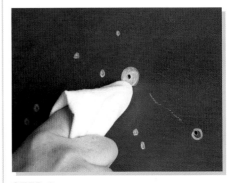

STEP 8

Use a cloth to wipe off any sawdust and dust around the holes, then use the white artist's acrylic to touch up the inner edges of the drilled holes.

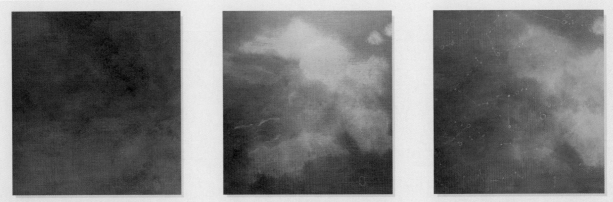

STAGE 1 **STAGE 2** **STAGE 3**

ADDING DEPTH

Before painting any details, to increase the depth of color in your night sky use layers of glaze over the base coat. Mix up approximately 10 oz. (300 ml) of uncolored glaze (follow the recipe on page 16). Divide into two containers. Tint the first glaze with 6 drops of ultramarine, 6 drops of cobalt blue, and 6 drops of viridian green tint colorant to make a dark turquoise blue transparent glaze. Apply with a dampened decorator's sponge and hog hair softener (see colorwash techniques, page 17). Allow to dry fully. Tint the second glaze with 6 drops ultramarine, 6 drops cobalt blue, 10 drops violet, and 5 drops of black tint colorant to make a dark indigo blue transparent glaze. Apply with a large dampened natural sea sponge in mottled patches and soften with a badger softener (see sponge glaze techniques, page 17). Allow to dry fully.

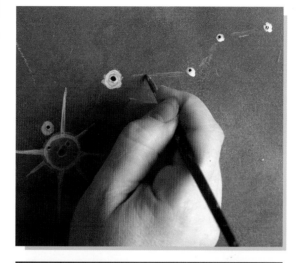

STEP 9

Use the glow in the dark paint on a fine sable brush to lightly paint in the dotted lines of the constellations and some of the star markings. To make this shine in the dark the painted area needs to be exposed to strong light for a period.

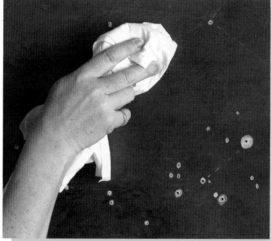

STEP 10

Once dry, use a cloth to remove any remaining chalk marks from the painting. The board is now ready to be hung. For real drama fix a light on the wall or ceiling behind the board so that it shines through the small drilled holes in the board. You can even use a string of decorative lights set to pulsing/intermittent frequency to emulate the twinkling of stars through the atmosphere.

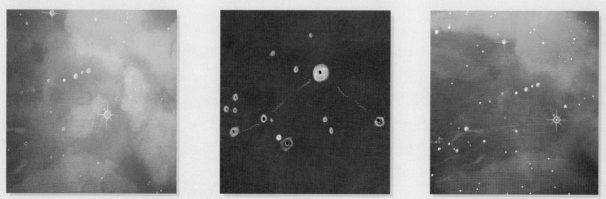

STAGE 4 STAGE 5 STAGE 6

BABY TRIPTYCH

The Baby Triptych is a charming three-panel project made up of two beautiful hand-painted panels with alphabet illustrations and colored numbers, and a central blackboard panel for all younger artists' inspirations! Use the color illustrations of the animals on page 126 to guide your color choices when painting, or decide on your own colors to create a real treasure for any child's room.

PAINTING MATERIALS

PREPARATION: Prepare the three battened boards following the instructions on page 9 and base paint two of them with two coats of pale cream matte emulsion, sanding between coats. Use a tack rag to remove all traces of dust, then varnish both boards with one coat of acrylic matte varnish. Sand the third board to create as smooth a surface as possible and seal it with one coat of matte acrylic varnish. Once dry, apply three to four coats of blackboard paint using a synthetic paintbrush. Sand each layer once dry and remove the black dust with a tack rag.

Refer to page 126 for color illustrations of the other animals.

SEE ALSO:
DRAWING TECHNIQUES, PAGE 12
PAINTING TECHNIQUES, PAGE 14

STEP 1

Using a photocopier, enlarge or reduce each of the linear images, letters, and numbers on pages 123–125 in the Templates section by the percentages given. Refer to the layout in the illustrations below (Stages 1 and 2) to see the arrangement of the illustrations for each board. Slide pieces of blue wax-free transfer paper face down under each illustration and carefully draw over the outlines until they are all transferred to the boards.

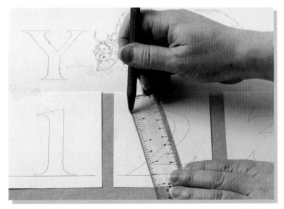

STEP 2

Lay out the numbers on the bottom third of the P to Z board using lightly penciled ruler marks to ensure straightness. Next, place the transfer paper under the numbers and draw over the outlines with a biro or hard pencil, using a ruler for straight edges.

STEP 3

To choose colors for each of the illustrations, refer to the colored illustrations on page 126 for guidance. Work on one illustration at a time and follow the guidelines described here for the parrot to paint each illustration. Use the main colors to block fill the area of the body of the animal first. Here, use turquoise and royal blue mixed with cobalt, cerulean, and ultramarine to paint the parrot's plumage from head to tail. Next paint the yellow chest using cadmium yellow and yellow ocher.

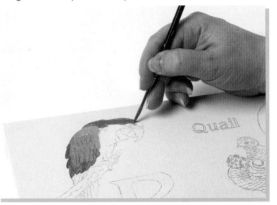

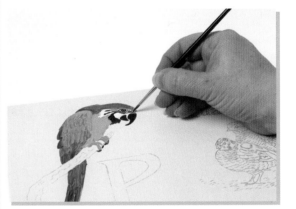

STEP 4

Once you have blocked in the main areas of color, progress to adding areas of more detail or shade, in this example the black markings on the face and beak of the parrot should be painted with black mixed with ultramarine and alizarin crimson. Also add in extra details of feather or fur markings, or extra light and dark areas.

STAGE 1 **STAGE 2** **STAGE 3** **STAGE 4**

STEP 5

Paint in background and surrounding details such as grass or rocks—in this example the branch on which the parrot is perched, which should be painted with raw umber and burnt sienna.

STEP 7

To paint the animal names, mix a medium gray using cobalt blue, burnt sienna, and white and paint each name as carefully as possible with a fine sable brush. Mix enough paint to paint all of the animal names at the same time, to avoid color differences over the boards.

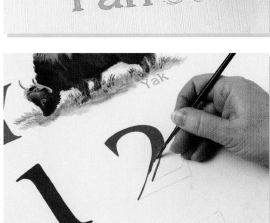

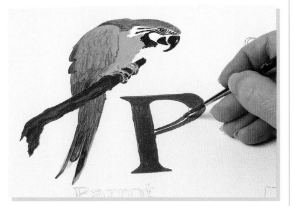

STEP 6

To paint the capital alphabet letter, mix a color that either contrasts or harmonizes with the animal illustration, then use a fine sable brush to paint the outline as steadily as possible and fill the spaces between. The letter may need a further one or two coats of paint to achieve full opacity, so mix enough paint for this.

STEP 8

The numbers 1 to 10 are painted in the colors of the rainbow plus baby blue, baby pink, and gold. (1–red; 2–orange; 3–yellow; 4–green; 5–blue; 6–indigo; 7–violet; 8–baby blue; 9–baby pink; 10–gold.) Use a fine sable brush to paint each outline as steadily as possible and then fill the spaces between. The number may need a further one or two coats of paint to achieve full opacity.

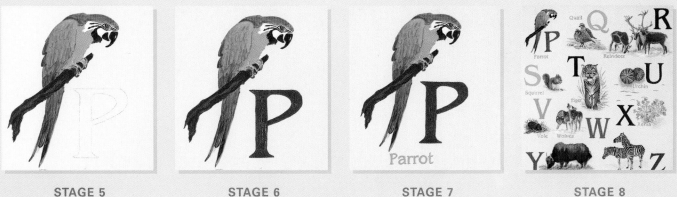

STAGE 5 STAGE 6 STAGE 7 STAGE 8

TEMPLATES

Linear templates are given here for the following projects: Japanese and Chinese Calligraphy; Botanical Mural; Waterside Mural; and Baby Triptych. Use the enlargement percentages given with each template to enlarge or reduce on a photocopier.

BOTANICAL MURAL, PAGES 44–47 (ENLARGE BY 400%)

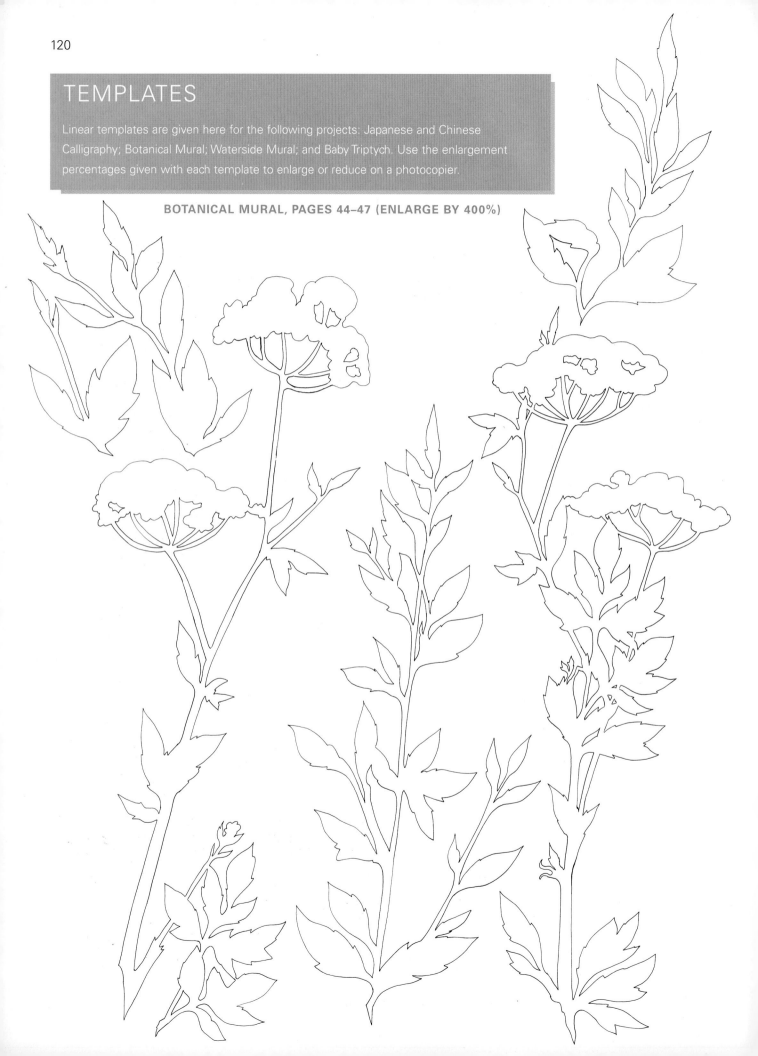

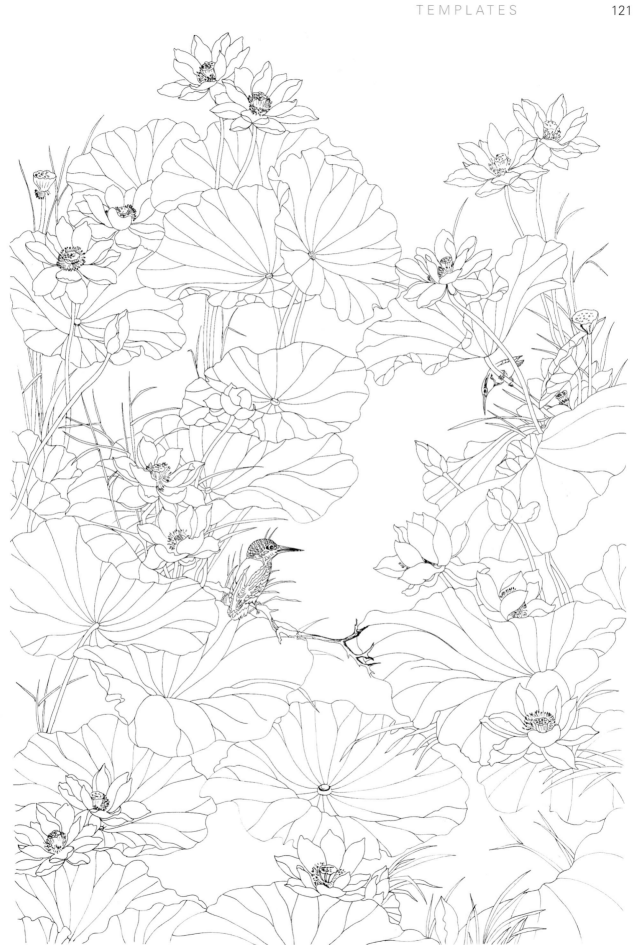

WATERSIDE MURAL, PAGES 60–63 (ENLARGE BY 470%)

JAPANESE AND CHINESE CALLIGRAPHY, PAGES 40–43 (ENLARGE BY 355%)

PEACE (JAPANESE SCRIPT)

BEAUTY (JAPANESE SCRIPT)

LOVE (JAPANESE SCRIPT)

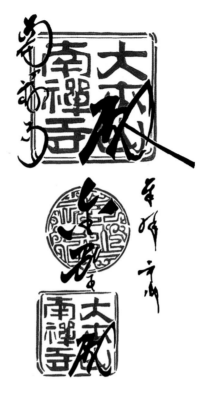

JAPANESE TEMPLE CALENDAR

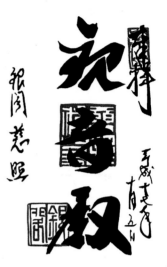

JAPANESE TEMPLE CALENDAR

ANCIENT CHINESE SCRIPT

BABY TRIPTYCH (LETTERS AND NUMBERS), PAGES 116–119
(FOR LARGE LETTERS AND NUMBERS, ENLARGE BY 320%
FOR WORDS, PHOTOCOPY AT 55%)

ABCDEFGH
IJKLMNOPQ
RSTUVWXY
Zabcdefghij
klmnopqrst
uvwxyzàåäö
æøçñéôü12
34567890

BABY TRIPTYCH (IMAGES), PAGES
116–119 (ENLARGE BY 286%)

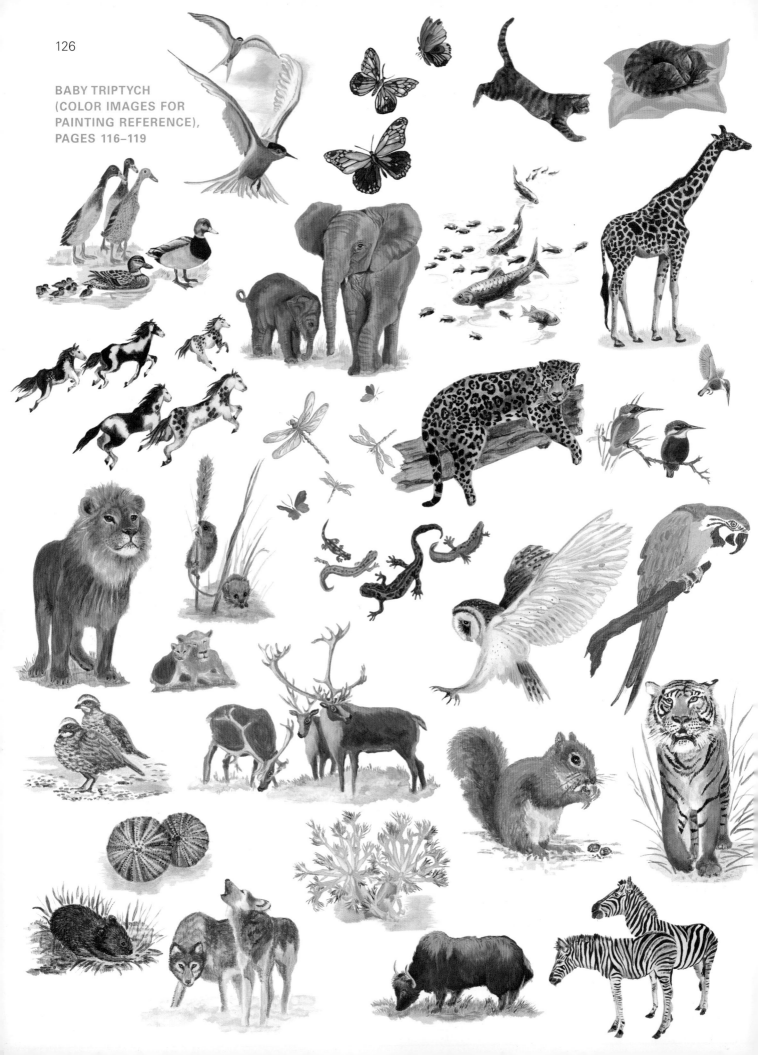

BABY TRIPTYCH
(COLOR IMAGES FOR
PAINTING REFERENCE),
PAGES 116–119

RESOURCE DIRECTORY

STENCIL SUPPLIERS

HENNY DONOVAN MOTIF
Tel: +44 (0)20 8340 0259
Web: www.hennydonovanmotif.co.uk
Original range of stencils used in this book include Bamboo and Moon, Agapanthus (Flower Blooms project), Chinoiserie Stencils (Chinoiserie Panels project), Polka Dot Repeat (Polka Dot Circles project), Giant Hogweed (Botanical Mural project), Oversize Wild Rose (Wild Rose Stencil project), and Butterflies (Butterfly Sky project). The designs used in the Blossom Bough and Orchid Découpage projects are also available as stencils. A full range of decorative paints and equipment is also available: stencil paints, metallic and glitter paints, interference paints, fabric paints, universal tint colorants, acrylic varnishes and scumble glaze, stencil equipment, and a wide range of brushes. International online shopping with worldwide mail order service.

DESIGNER STENCILS
2503 Silverside Road
Wilmington, DE 19810
Tel toll free: 1 800 822 7836
Tel: (302) 475 7300
Fax: (302) 475 8644
Web: www.designerstencils.com
Over 1100 precut stencil designs, including lettering, plus supplies.

DOVER PUBLICATIONS
31 East 2nd Street
Mineola, NY 11501
Fax: (516) 873 1401
Web: www.doverpublications.com
Reference books, period paints, ready-to-cut stencil designs.

DRESSLER STENCIL COMPANY
253 SW 41st Street
Renton, WA 98055
Tel toll free: 1 888 656 4515
Fax: (415) 656 4381
Web: www.dresslerstencils.com
Over 300 precut stencil designs.

THE MAD STENCILIST
P. O. Box 219 Dept N
Diamond Springs, CA 95619
Tel toll free: 1 888 882 6232
Tel: (530) 344 0939
Fax: (530) 626 8618
Email: questions@madstencillist.com
Web: www.madstencilist.com
Over 170 precut stencil designs.

THE SIMS COLLECTION
24 Tower Crescent
Barrie, ON L4N 2V2
Tel: (705) 725 0152
Fax: (705) 725 8637
Email: sales@simsdesign.com
Web: www.simsdesign.com
Precut stencils in whimsical designs.

ARTIST'S MATERIALS AND SPECIALIST PAINTS

GOLDEN ARTIST COLORS, INC.
188 Bell Road
New Berlin, NY 13411-9527
Tel toll free: 1 800 959 6543
Fax: (607) 847 6767
Web: www.goldenpaints.com
Artists' acrylic paints, retardants, mediums, and varnishes. Online dealer locator.

PEARL PAINTS
1033 East Oakland Park Boulevard
Fort Lauderdale, Fl 33334
Tel toll free: 1 800 451 7327
Tel: (954) 567 9678
Web: www.pearlpaint.com
Paints and fine art supplies, including metallic varnishes, gilding creams and waxes, white shellac, button polish shellac, gold leaf products, and dry pigments. Online retail location directory.

SEPP LEAF PRODUCTS
381 Park Avenue South
New York, NY 10016
Tel toll free: 1 800 971 7377
Tel: (212) 683 2840
Fax: (212) 725 0308
Email: sales@seppleaf.com
Web: www.seppleaf.com
Gold and metal leaf, plus supplies and tools. Gilding creams and waxes, and wood finishing. Metallic varnishes, white shellac, and button polish shellac.

SINOPIA LLC
3385 22nd Street (near Guerrero)
San Francisco, CA 94110
Tel: (415) 824 3180
Fax: (415) 824 3280
Email: pigments@sinopia.com
Web: www.sinopia.com
Gilding materials, specialty brushes, shellacs, waxes, varnishes, acrylic glazing liquids. Online catalog.

PAINTING AND DECORATING RETAILERS AND SUPPLIERS

BRIWAX WOODCARE PRODUCTS
220 South Main Street
Auburn, ME 04210
Tel toll free: 1 800 274 9299
Fax: (212) 504 9550
Email: information@briwaxwoodcare.com
Web: www.briwaxwoodcare.com
Shellacs, varnishes, and wood waxes.

CONSTANTINES WOOD CENTER
1040 E. Oakland Park Blvd.
Ft. Lauderdale, FL 33334
Tel toll free: 1 800 443 9667
Fax: (954) 565 8149
Web: www.constantines.com
Metallic varnishes, gilding creams and waxes, white shellac, button polish shellac, gold leaf products.

LIBERON/STAR WOOD FINISH SUPPLY
P. O. Box 929
Fort Bragg, CA 95437
Email: wfs@woodfinishsupply.com
Web: www.woodfinishsupply.com
Wood finishing materials, paints and varnishes. Online dealer locator.

MOHAWK FINISHING PRODUCTS INC.
P. O. Box 22000
Hickory, NC 28603-0220
Tel toll free: 1 800 545 0047
Tel: (828) 261 0325
Fax: (800) 721 1545
Web: www.mohawk-finishing.com
Varnishes, polishes, and shellacs.

PRATT AND LAMBERT INC.
PO Box 22
Buffalo, NY 14240
Tel: (800) 289 7728
Web: www.prattandlambert.com
Paints, ready-mixed glazes and varnishes. Online store locator.

WOODCRAFTER'S SUPPLY CORP.
PO Box 1686
Parkersburg, WV 26012-1686
Tel toll free: 1 800 225 1153
Fax: (304) 428 8271
Email: custserv@woodcraft.com
Web: www.woodcraft.com
Varnishes.

TIMBER MERCHANTS FOR MDF AND WOOD

THE HOME DEPOT
Tel toll free: 1 800 553 3199
Web: www.homedepot.com
Building and decorating supplies. Online orders and store locator.

LEE VALLEY TOOLS LTD.
P. O. Box 6295, Station J
Ottawa, ON K2A 1TA
Tel toll free: 1 800 267 8767
Fax toll free: 1 800 668 1807
OR
P. O. Box 1780
Ogdensburg, NY 13669-6780
Tel toll free: 1 800 871 8158
Tel: (613) 596 0350
Fax toll free: 1 800 513 7885
Fax: (613) 596 6030
Email: customerservice@leevalley.com
Web: www.leevalley.com
Woodworking and hardware supplies. Mail order and Canadian locations.

LOWE'S
P.O. Box 1111
North Wilkesboro, NC 28656
Tel toll free: 1 800 455 6937
Web: www.lowes.com
Building and decorating supplies. Online orders and store locator.

PHOTOGRAPHIC AND PHOTOCOPYING SUPPLIERS

FEDEX KINKO'S OFFICE AND PRINT SERVICES, INC.
Three Galleria Tower
13155 Noel Road, Suite 1600
Dallas, TX 75240
Tel toll free: 1 800 254 6567
Tel: (214) 550 7000
Email: customerrelations@fedexkinkos.com
Web: www.kinkos.com
Printing and photographic supplies and services. Online store locator.

OFFICE MAX
3605 Warrensville Center Road
Shaker Heights, OH 44122
Tel toll free: 1 877 4THE MAX
Tel: (216) 921 6900
Web: www.officemax.com
Printing and photographic supplies and services. Online store locator.

STAPLES
Tel toll free: 1 800 378 2753
Web: www.staples.com
Printing and photographic supplies and services. Online store locator.

TEXTILE SUPPLIES

HANCOCK FABRICS
One Fashion Way
Baldwyn, MI 38824
Tel toll free: 1 877 322 7427
Web: www.hancocksfabrics.com
Textiles, needlework, and home decorating supplies. Online orders and store locator.

JO-ANN FABRIC & CRAFTS
5555 Darrow Road
Hudson, OH 44236
Tel toll free: 1 888 739 4120
Tel: (330) 656 2600
Web: www.joann.com
Textiles and needlework supplies. Online orders and store locator.

MODERN FURNITURE

RJM FURNITURE
213-215 New North Road
London N1 6SU
Tel: 0800 0015 888
Fax: (020) 7251 9009
Web: www.rjmfurniture.com
Email: info@rjmfurniture.com
Contemporary designer furniture.

INDEX

ACKNOWLEDGMENTS

This book is dedicated to my parents, Olwen and Anthony Carthew, for the opportunities they created for me, and their love and support through the years.

Thanks and acknowledgments to

• The Quarto team—Jo Fisher, Natasha Montgomery, and Penny Cobb for their work on this book.

• Phil Wilkins for photography of all steps and projects, and for hours of patience and good humor!

• Kai Miller for his excellent blackboard work for the Baby Triptych project and Sam Miller for bringing him to the shoot.

• Keith Bourdice for carpentry for the Food Art and Waterside Mural projects.

• Zoe Miller for the use of her home for location shots for the Flower Blooms and Photographic Art projects.

• Henny Donovan for the use of her home for location shots for the Bamboo and Moon and Wild Rose Stencil projects.

• Henny Donovan Motif for supplying all stencils and paints for the projects.
Tel: +44 (0)20 8340 0259
www.hennydonovanmotif.co.uk

• Laser Cutting Services Ltd, Scotland for stencil manufacture and fine laser cutting of Henny's designs.
Tel: +44 (0)1360 850389
www.lasercutit.co.uk

• RJM Furniture Ltd for allowing us to photograph their showroom and contemporary furniture.
Tel: +44 (0)800 0015 888
www.rjmfurniture.com

• A.S. Handover Ltd for equipment and materials.
www.handover.co.uk

• John Jones for art materials.
www.johnjones.co.uk

• Wm. C. Thomerson Ltd, Crouch End, London for timber and timber cutting.
Tel: +44 (0)20 8340 2742

• Foto Plus, Crouch End, London for photographic enlargements and frames.
Tel: +44 (0)20 8340 7316

• Image bottom left, page 107 © Fuji Photo Film Ltd

Quarto would like to acknowledge the following photographers:

p2, 48, 64, 86, 94 Jan Baldwin/Narratives

p58 Peter Dixon/Narratives

p106 Mark Lund/The Image Bank/Getty

All other photographs are the copyright of Quarto Publishing plc. While every effort has been made to credit contributors, Quarto would like to apologize should there have been any omissions or errors and would be pleased to make the appropriate correction for future editions of the book.